IMAGES
of America

PARK RIDGE

IMAGES
of America

PARK RIDGE

David Barnes

ARCADIA
PUBLISHING

Published by Arcadia Publishing
Charleston, South Carolina

Printed in the United States of America

Library of Congress Control Number: 2009940707

For all general information contact Arcadia Publishing at:
Telephone 843-853-2070
Fax 843-853-0044
E-mail sales@arcadiapublishing.com
For customer service and orders:
Toll-Free 1-888-313-2665

Visit us on the Internet at www.arcadiapublishing.com

*Dedicated to the many friends I have made in Park
Ridge and to the memory of those I have lost.*

CONTENTS

ACKNOWLEDGMENTS

A book of this kind is a compilation of memories, images, letters, written accounts, and historical records gathered from a variety of sources ranging from family members to established institutions such as the Park Ridge Public Library and the Park Ridge Historical Society.

My role was simply to collect the raw materials and present them, I hope, in an informative way. But that would have been impossible without the support of my many contributors.

For their invaluable assistance, I thank photographers Dave Chare, Don Pfister, and Diddy Blyth of A Sterling Design. My thanks also to Amber Ensign of the Park Ridge Public Library, Paul Adlaf of the Park Ridge Historical Society, John Larson of the Park Ridge Country Club, Marcia Opal of Lutheran General Hospital, Dave Beery of Maine Township High School District 207, Andrew Wilson, and Brian Lazzaro for making their collections of historic images available for this publication.

John Kainer of McHenry, Illinois, and the Kartheiser family, both formerly of Park Ridge, also contributed historic family photographs along with Fred Gillick, Bill Scharringhausen, Rick Cubberly, and John Heinz—my thanks to them all.

Lending facts, figures, and ongoing support, in addition to those already mentioned, were Herb Zuegel, Betsy Foxwell, and Burt Olsson of the Kalo Foundation, retired fire department captain Ralph Bishop, Susan Tedeschi of the city's public works administration, Jennifer Johnson with the Park Ridge Herald-Advocate, Ed McCabe of the Park Ridge Heritage Committee, and Denise Alberts who assisted with research.

Finally I would be remiss if I did not thank my editor, Jeff Ruetsche, and my publisher, John Pearson, for their patience and understanding when it was needed most.

Unless otherwise indicated, all photographs are in the public domain.

INTRODUCTION

Stretching north and west from the intersection of Lawrence Avenue and East River Road in unincorporated Norridge is a 500-acre tract of Cook County Forest Preserve known as Robinson's Woods. Just inside the woods off East River Road is a stone monument memorializing Alexander Robinson who, along with his wife, is buried there. The casual passerby might assume that Robinson must have been an important early settler to be buried in the woods that bears his name. And he would be right.

But Robinson was not one of those Johnny-come-lately Yankees who began trickling into the area in the 1830s. Robinson was chief of the local Potawatomi, Chippewa, and Ottawa Indians who had lived along the banks of the Des Plaines River for more than 200 years.

The Chicago Treaty of 1833 enabled the federal government to buy some 5 million acres of land east of the Rock River from the Native Americans for 15¢ an acre in exchange for a reservation of the same size west of the Mississippi. The tribes had three years to move west, and northeast Illinois was now open for white settlement.

But some indigenous inhabitants, including Robinson, were encouraged to stay. Partly out of gratitude for having kept his people out of the Blackhawk War and for having saved the lives of several Chicago pioneers, including John Kinzie and his family during the Fort Dearborn Massacre, Robinson was granted "two sections on the Rivere Aux Pleins," including his namesake woods.

Another prominent Potawatomi leader who stayed behind was Billy Caldwell, also known as Chief Sauganash, the half-breed son of a Mohawk mother and Irish father. Caldwell was granted 1,600 acres in the area that now bears his name, eventually selling the land and moving to what is now Council Bluffs, Iowa.

Robinson continued to live on his land until 1872, reaching, by some accounts, the age of 110. He was buried next to his wife, Catherine, on the family homestead, which Robinson's descendents continued to inhabit until the 1950s.

As the area referred to by local Native Americans as Shikaakwa began to develop into a major crossroads attracting merchants and land speculators in the 1830s and 1840s, a more bucolic crossroads to the northeast of Robinson's spread appealed to a different type of settler. That crossroads—today's Touhy Avenue and Northwest Highway—is now the heart of the Park Ridge business district.

With most of the Native Americans relocated to the West, Yankee farmers began migrating from New England and upstate New York. One of the earliest was Capt. Mancel Talcott, who brought his family west from Rome, New York, traveling by flatboat on the Erie Canal to Detroit and then on foot to a tract of land next to the Des Plaines River near what is now Touhy Avenue. There he built a log cabin in 1834 that, three years later, became the first post office outside of Chicago. For some mysterious reason it was called Chamblee.

Following Talcott from the east was Socrates Rand, who began farming the land where his namesake road now crosses the Des Plaines River in 1835. A community builder, Rand opened his home for Episcopal services in 1837 and, one year later, operated the area's first school.

Sister Harriet did the teaching. Rand was also the first justice of the peace, performing the area's first wedding.

After a group of speculators known as the Illinois and Wisconsin Land Company developed plans to build a railroad from Chicago to Janesville, Wisconsin, Rand provided the necessary timber to feed the new Chicago, St. Paul, and Fond du Lac (CSP&FDL) Railroad's sawmill. In 1859, when the Chicago and North Western bought the CSP&FDL, the railroad named the stop at Rand's farm Des Plaines.

Dr. Silas Meacham arrived in 1836 and built a cabin near present-day Touhy Avenue and Dee Road, not far from Mancel's spread. Heading west from Vermont by way of New York State with brothers Lyman and Harvey, Silas reached present-day Bloomingdale three years earlier where the trio farmed 1,200 acres in the area now known as Medinah, home of the Medinah Country Club. It is not clear why Silas continued north, but he remained in Maine Township until his death in 1852 at age 61.

Early roads in the area generally followed long-established Native American trails but one—present-day Touhy Avenue—took on particular prominence as the shortest link, or portage, connecting the Chicago River with the Des Plaines River. In an era when most goods traveled by water, it played a vital role in transshipping incoming merchandise from the East to the pioneering farmers in the West. It would also be central to the development of the modern city of Park Ridge.

In 1840, federal land surveyors Jarius Warner and Thomas Stevens were charged with laying out a road linking Rand (now Des Plaines) with Chicago. Their cabin on what is known today as Northwest Highway, just west of its present intersection with Touhy, was the first dwelling raised in downtown Park Ridge.

Five years later, Mancel Talcott Jr. bought 160 acres of land, stretching south from modern Touhy Avenue to Belle Plaine Avenue and east from Cumberland Avenue to Washington Avenue. There he built a house on the eastern corner of Touhy Avenue and Northwest Highway, later to become the site of a succession of banking institutions.

In 1853, the 28-year-old George W. Penny arrived from New York, lured by the rich clay deposits that lent themselves to the production of high-quality bricks. Striking a partnership with Robert Meacham, Penny began mining the clay and making bricks near today's Grand Boulevard and Meacham Avenue.

The area around Penny's clay pits was locally known as Pennyville, but in 1855 Penny himself insisted that the unincorporated town be renamed Brickton. Was it out of modesty or a clever way to draw attention to his business interests? The record is silent.

Whatever the reason, Penny and Meacham's bricks were soon in demand in a burgeoning Chicago. But with the railroad stopping only at Edison Park and Des Plaines, there was no convenient way to ship those bricks south. By 1856, Penny had built a depot with his bricks and convinced the railroad to run a spur to his brickworks, opening the way for his company to feed as many as five million bricks a year to the growing metropolis.

In 1873, with a population of 405, the residents decided it was time to incorporate. A total of 57 votes were cast, and the Village of Park Ridge was officially placed on the map. Its first president, George B. Carpenter—a refugee from the Great Chicago Fire—suggested the name, linking the community's park-like ambience with the pronounced Smith's Ridge running along today's Prospect Avenue. The name also had a nice sound to it.

On the Fourth of July in 1873, the city fathers launched an unmanned 20-foot hot-air balloon that had crashed in Park Ridge a week earlier. Patched and decorated with the name "Brickton," it was sent on its last recorded flight. After narrowly missing the Methodist church steeple, it disappeared over the eastern horizon. Where it landed again may never be known, but the name change was now official.

One

FOUNDING FATHERS

For the early pioneers like Mancel Talcott, Socrates Rand, and others, life on the newly opened prairie was as much a challenge as an opportunity. The typical farmer in the 1840s lived in a drafty cabin, raised wheat for his bread and chickens for his eggs and Sunday dinner. He may have had a cow to supply his milk, butter, and cheese. And he would likely have had a horse to provide needed muscle.

But as more settlers began to farm the land, a budding commerce was not far behind, as merchants saw an expanded market for their goods. Blacksmith Miller set up shop where the library now stands. And, unique to the area, Charles Penny launched an industry that ultimately employed more than 100 tradesmen.

Most of the developing commerce centered on the intersection of the newly platted road linking present-day Des Plaines with Chicago and the east-west portage between the Chicago and Des Plaines Rivers. It was there that Penny built his home, the railroad station, and the brick, two-story emporium that still stands at 11 North Northwest Highway.

Informally called Pennyville after its leading industrialist, a viable community was beginning to emerge from gently rolling prairie.

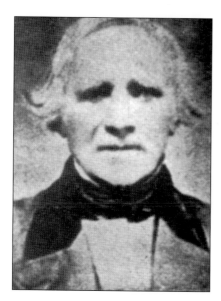

Chief Alexander Robinson, also known as Chee-Chee-Pin Qua, or "Blinking Eye" for a pronounced facial tic, was chief of the local Potawatomi, Chippewa, and Ottawa Indians, although by some accounts he was only one-sixth Native American. Following the Chicago Treaty of 1833, Robinson was granted "two sections [of land] on the Rivere Aux Pleins" by a grateful federal government.

A simple stone monument marks the graves of Chief Alexander Robinson and his French wife, Catherine. The monument is a few yards west of East River Road in unincorporated Norridge, about a quarter-mile north of Lawrence Avenue. Catherine died in 1860, but Robinson lived on for another 12 years, dying, by some accounts, at age 110. (Author's collection.)

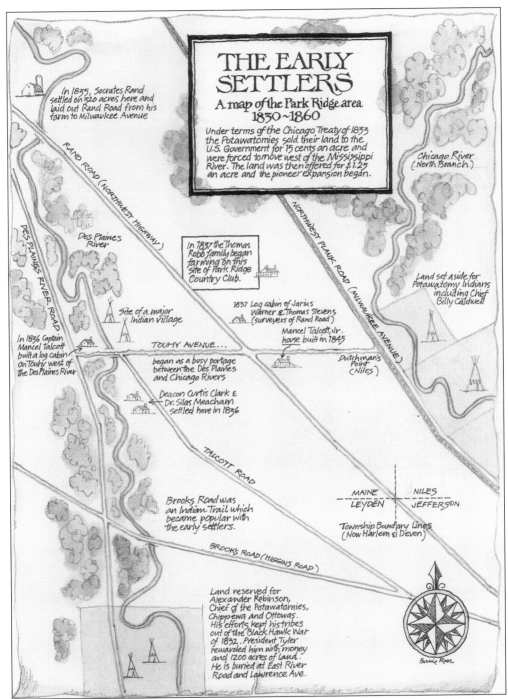

THE EARLY SETTLERS

A map of the Park Ridge area 1830~1860

Under terms of the Chicago Treaty of 1833 the Potawatomies sold their land to the U.S. Government for 15 cents an acre and were forced to move west of the Mississippi River. The land was then offered for $1.25 an acre and the pioneer expansion began.

In 1835, Socrates Rand settled on 320 acres here and laid out Rand Road from his farm to Milwaukee Avenue

RAND ROAD (NORTHWEST HIGHWAY)

DES PLAINES RIVER ROAD

Des Plaines River

In 1837 the Thomas Robb family began farming on this site of Park Ridge Country Club.

Site of a major Indian village

In 1836 Captain Mancel Talcott built a log cabin on Touhy west of the Des Plaines River

TOUHY AVENUE...

began as a busy portage between the Des Plaines and Chicago Rivers

Deacon Curtis Clark & Dr. Silas Meacham settled here in 1836

1837 Log cabin of Jarius Warner & Thomas Stevens (surveyers of Rand Road)

Mancel Talcott, Jr. house built in 1845

NORTHWEST PLANK ROAD (MILWAUKEE AVENUE)

Chicago River (North Branch)

Land set aside for Potawatomy Indians including Chief Billy Caldwell

Dutchman's Point (Niles)

TALCOTT ROAD

Brooks Road was an Indian Trail which became popular with the early settlers.

MAINE | NILES
LEYDEN | JEFFERSON

Township Boundary Lines (Now Harlem & Devon)

BROOKS ROAD (HIGGINS ROAD)

Land reserved for Alexander Robinson, Chief of the Potawatomies, Chippewa and Ottowas. His efforts kept his tribes out of the Black Hawk War of 1832. President Tyler rewarded him with money and 1200 acres of land. He is buried at East River Road and Lawrence Ave.

Bernie Roer

This is a modern map of what the Park Ridge area would have looked like in the mid-1840s after Capt. Mancel Talcott built his cabin just west of the Des Plaines River. Former Native American trails are depicted with their modern names, including Touhy Avenue, then a major east-west portage between the Chicago and Des Plaines Rivers. (Courtesy of Bernie Roer.)

11

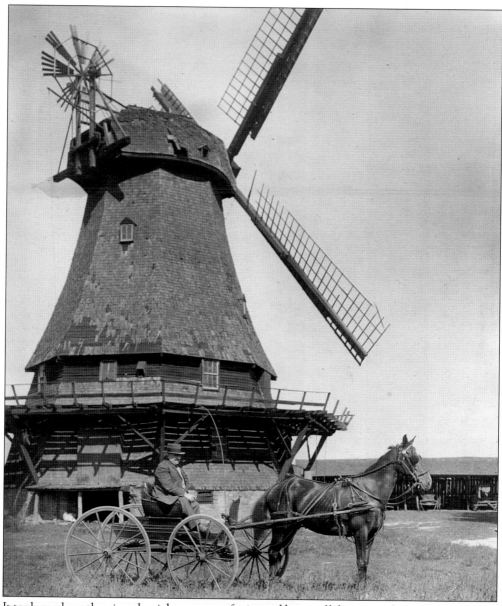

It took good weather, just the right amount of rain, and hours of labor to produce a farmer's crops. But to turn his grain into a useful commodity, he needed the services of this wind-powered gristmill, located south of Higgins Road near River Road. (Courtesy of the Park Ridge Public Library.)

In 1845, Mancel Talcott Jr. purchased 160 acres extending from Touhy Avenue south to Belle Plaine Avenue and from Cumberland Avenue east to Washington Avenue. He built his home at the apex of Touhy and South Northwest Highway. Born in 1817 in Rome, New York, Talcott caught the "gold fever" in 1849 and was one of the first 49ers to reach California, returning to Park Ridge in 1852. He died June 5, 1878, and is interred in the Town of Maine Cemetery.

If the Des Plaines River was the gateway to the West, what is now Park Ridge was, in the 1830s, its welcome mat. The vital portage that is now Touhy Avenue linked the Chicago River with the Des Plaines, opening the way for needed goods to be transshipped to settlers migrating west. (Courtesy of Dave Chare.)

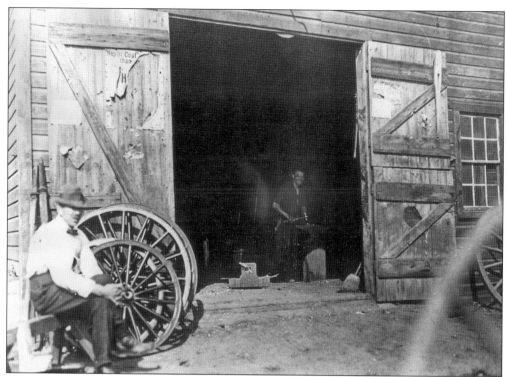

Just as important to the pioneer farmer as his horse and plow was the village smithy. Blacksmith Miller's anvil and forge were located on the triangle between Touhy, Prospect, and Summit Avenues, later the site of Central School and currently occupied by the Park Ridge Library. (Courtesy of the Park Ridge Public Library.)

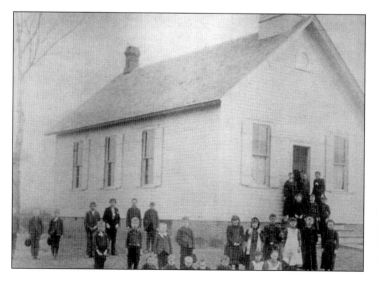

By 1841, early educational needs had outgrown Socrates Rand's modest facility, and a new school was built on the northwest corner of Higgins Road and Canfield Avenue. The Pennoyer School (shown here around 1893) was later moved and converted into a residence. A second Pennoyer School on the site was subsequently transformed into VFW Post 3579.

Two

THE COMMUNITY GROWS

By the turn of the 20th century, Park Ridge had evolved into a comfortable place to live and raise a family. Distant from the noise and crowding of the growing metropolis to the south, it offered most of the needed amenities while maintaining its bucolic atmosphere.

With the population topping 1,300 in 1900, Charles Kobow and Rudolph Brunst's grocery store on north Park Street (now Northwest Highway) was well established, as was Charles Stebbings's store that, built of Brickton bricks, still stands at 11 North Northwest Highway. A centrally located school was built on the site now occupied by the library.

A volunteer fire department was in place along with a modest police force headed by Charles Duwel, who would be appointed chief in 1901. Both departments shared space in the brick, two-story village hall built in 1896 on the west side of the intersection of Touhy Avenue and Northwest Highway.

The Electric Hall, on the northwest corner of Fairview Avenue and Main Street, not only supplied lighting to a growing number of homes that were being electrified, it also served as a place to hold meetings, parties, plays, and religious services. The Ridge Hotel, across from the train station on Main Street, provided accommodations for out-of-town guests.

With the clay pits all but exhausted, Park Ridge's leading industry had shifted to fresh vegetables that were grown in more than two dozen greenhouses, which began to spring up around town in the 1880s. There were the Erhardt greenhouses west of the village along the banks of the Des Plaines River. Closer to town were the Heinz greenhouses on Northwest Highway between Elm Street and Greenwood Avenue. The last of their kind, they survived into the late 1960s when they were replaced with office buildings and the Jewel grocery store.

A number of subdivisions had been platted, including the one with curving streets laid out south of the railroad tracks by real estate developer Leonard Hodges, who also established the small park that bears his name in front of the current city hall.

On the social front, the George B. Carpenters opened his 18-room home to reading groups and for other cultural activities. The Park Ridge Woman's Club, established in 1894, would meet regularly to discuss the works of Dickens, Shakespeare, and other popular or classic authors.

From the simple crossroads of the 1850s, Park Ridge had established its own unique identity.

He came to Park Ridge in search of clay with which to manufacture bricks, ultimately providing 125 jobs to local residents. And he convinced the embryonic Chicago and North Western Railroad to put his town on the map. More than a pioneer, George Penny was the builder of the community that briefly bore his name. Although no photograph of George is known to exist, his son Charles (shown here) carried on his father's legacy of civic leadership during the early decades of the 20th century.

By 1856, George Penny's brick business was well established, but shipping them to his Chicago market was a challenge since the railroad did not stop at Brickton. To solve the problem, Penny agreed to build and maintain this depot just south of Prospect. In exchange, the railroad ran a spur to his plant at Meacham Avenue and Northwest Highway.

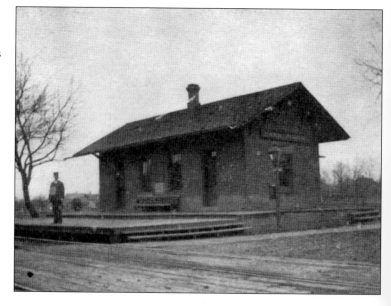

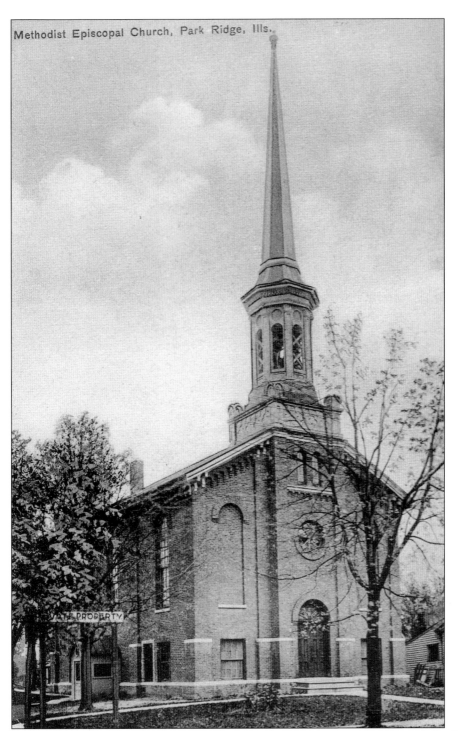

Methodist Episcopal Church, Park Ridge, Ills.

One of the first local buildings constructed of Brickton bricks, at a cost of $6,000, was the First Methodist Church on present-day Touhy Avenue. For a time, services alternated between Methodist and Congregational. The church was greatly expanded in 1925 with the present structure all but replacing the original buildings in 1956. (Courtesy of Brian Lazzaro.)

About the time he built the Brickton railroad station, George Penny added this general store to the landscape. It also served as the Brickton Post Office, established in 1857. From 1911 to 1913, the second floor housed the library with a rent of $5 a month. Merchandiser Charles Stebbings, who doubled as postmaster, rented the store in 1865, bought it in 1872, and ran it until the turn of the 20th century when he moved to larger quarters at Prospect and Summit Avenues. Located at 11 North Northwest Highway, it is probably the last Brickton brick building still standing in Park Ridge.

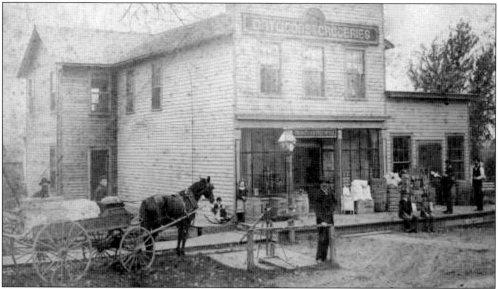

Just down the street from Stebbings brick building was the Brunst and Kobow store, shown here as it looked in 1886. In addition to general merchandise, the store also offered meats and groceries. Legend has it that Charles Kobow inadvertently started the move toward incorporation by telling a local minister in jest that he planned to open a saloon in his new addition. To prevent John Barleycorn from setting foot in the community, there had to be a law, and to get a law, one had to have an incorporated legal entity. (Courtesy of the Park Ridge Historical Society.)

Settling in Brickton after the Great Chicago Fire of 1871, ship and railroad supplier George B. Carpenter served as the first president of the new village of Park Ridge. A contest had been staged among its 405 residents to select a name for the village. With about 100 names suggested, Carpenter's won out based on a combination of the bucolic lay of the land with the pronounced Smith's Ridge that defines today's Prospect Avenue. Was first prize the village presidency or was Carpenter's election a coincidence?

Known affectionately as "Uncle Sam," Sam Cummings wore many hats during the transition from Brickton to Park Ridge. After working on the railroad in 1854, he served as Brickton's first stationmaster, one-time postmaster, and newspaper deliveryman with the assistance of his horse Dan. He also served as the first village clerk, a post he held for 17 years. (Courtesy of the Park Ridge Public Library.)

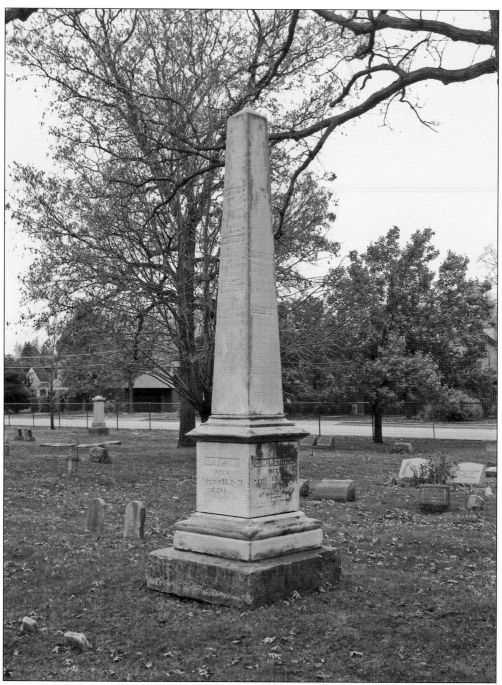

An obelisk marks the Penny family plot in the Town of Maine Cemetery; smaller, heavily weathered monuments ranged around its base mark individual graves. Believed to have once been a Native American burial ground, the Town of Maine is the oldest, still active cemetery in Maine Township. (Author's collection.)

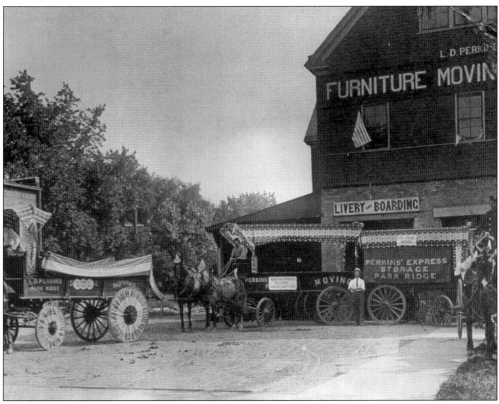

Electric Hall (below), at Main Street and Fairview Avenue, housed the city's power plant, with lines running as far as Jefferson Park. Its second floor served as a meeting hall, auditorium, and a place to hold parties, dances, and religious services. It was later converted to Perkins Express (above), a moving and storage facility. With wagons decked out in patriotic bunting, Perkins's draymen prepare for the 1911 Fourth of July parade. (Below, author's collection.)

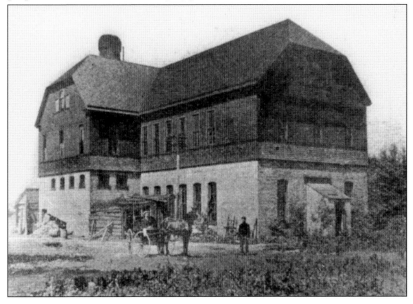

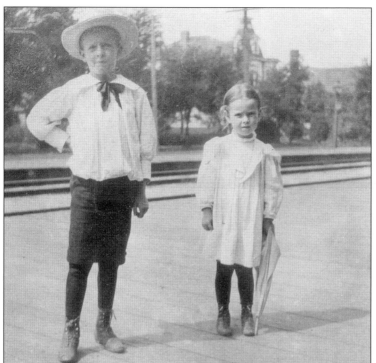

In an era when the kids were shooed out of the house after breakfast and told to be home in time for lunch, Russ and Anita Brooks stopped by the train station on a sunny day in 1889 to watch for a passing train. In the background behind Anita is the towering Cochran Mansion on the southwest corner of Main Street and Fairview Avenue. (Author's collection.)

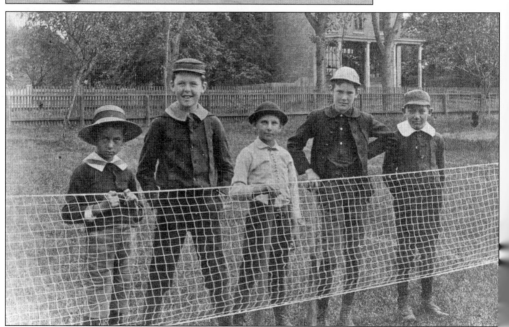

George B. Carpenter's estate, formed by the triangle bounded by North Northwest Highway, Touhy Avenue, and Summit Avenue, was a virtual private playground for Carpenter's sons and their friends. Pausing between their game somehow involving a baseball bat and badminton net in 1887 are, from left to right, Charles Penny, Alexis Colman, John Alden Carpenter, Fred Fricke, and Hubbard Carpenter. The store in background, built of Brickton bricks, still stands. (Author's collection.)

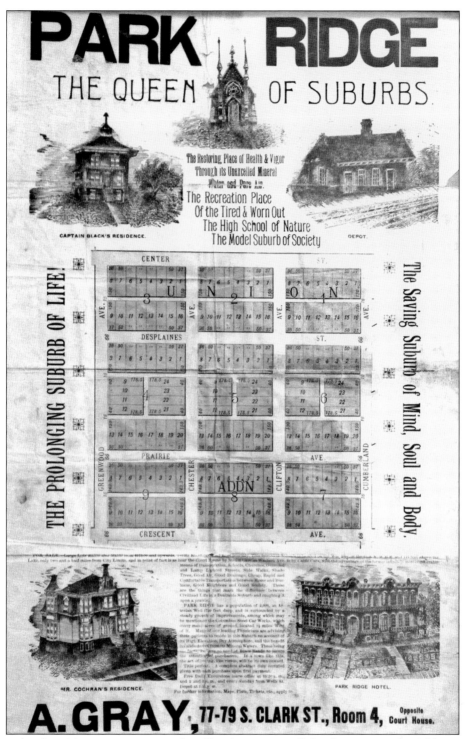

An early advertising poster promotes the village's pure water, lighted streets, good neighbors, and "good society." Billed as the "Queen of the Suburbs," it is "The Recreation Place of the Tired & Worn Out" and "The Model Suburb of Society." (Courtesy of Fred Gillick.)

An early real estate developer in "The Model Suburb of Society" was Fred I. Gillick, pictured here around 1900. Born in Park Ridge in 1876, he earned pocket money as a boy by caring for "Uncle" Sam Cummings's horse and cow. As a young attorney out of the Kent College of Law, he worked for a time with the Chicago and North Western's land department before embarking on his real estate career.

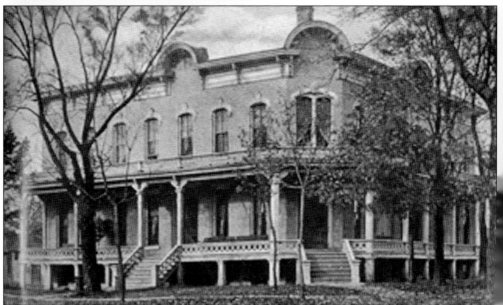

Another real estate developer, Leonard Hodges, built this hotel on Main Street in the 1870s. For years, it served as a gathering place for a number of community groups. Variously called Hodges Hall and the Ridge Hotel, it was later purchased by the Swedish Old Peoples Society and converted into a retirement home. In 1908, it was purchased by Fred I. Gillick and torn down in 1913 for expansion of the Gillick Building at Prospect Avenue and Main Street.

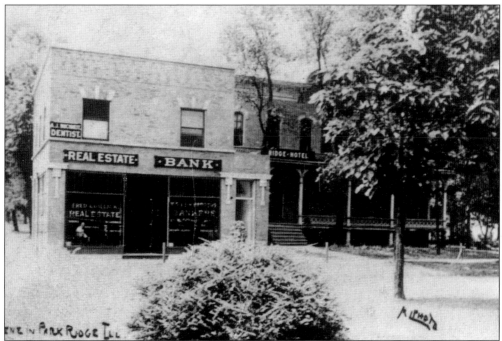

In 1908, W. G. and Stanley H. Barrows opened a banking department in their successful lumber and coal business on the northwest corner of Touhy and Summit Avenues. In less than a year, it became apparent that the bank had to move into more appropriate quarters. Barrows moved into Fred I. Gillick's building (above) on the corner of Prospect Avenue and Main Street in 1909, sharing half the floor space with the increasingly prominent real estate agent. Notice the Ridge Hotel behind the tree on the right of the Gillick Building. The same building (below) is pictured in the 1920s. (Above, courtesy of Fred Gillick; below, the Park Ridge Public Library.)

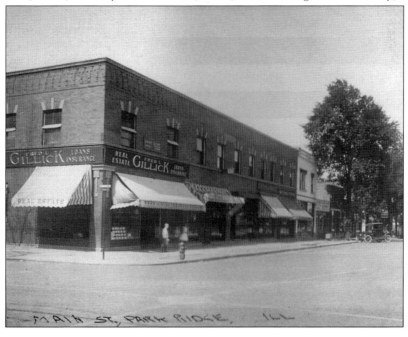

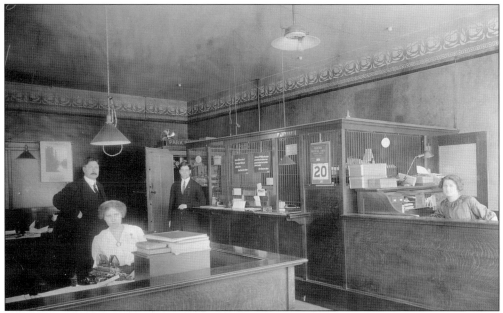

On Monday, January 20, 1913, Fred I. Gillick (left) took a minute to pose for the camera in the real estate side of his modest two-story building at Prospect Avenue and Main Street. The banking operations were conducted on the right. By this time, the bank started by the Barrows had been incorporated as the Park Ridge Bank with Stanley Barrows serving as president and Gillick as vice president. (Courtesy of Fred Gillick.)

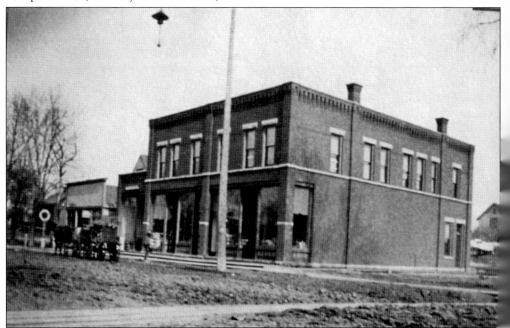

Perhaps outgrowing his original Northwest Highway location, Charles Stebbings moved his store to the corner of Prospect and Summit Avenues sometime around 1900. The telephone exchange was located on the second floor. Whenever a call came in for a resident, a messenger was dispatched to find the resident who would then take the call upstairs.

What the Pickwick Building has been to Park Ridge since 1928, the administration building was to the village as its prominent landmark at the end of the 19th century. Built on the west intersection of Touhy Avenue and Northwest Highway in 1896 to house the police and fire departments, it was strategically placed next to the artesian well that served as the village's water supply. The storage tower behind the building towers above the roof; an additional tower (below) was added within a decade. The building was torn down in 1948.

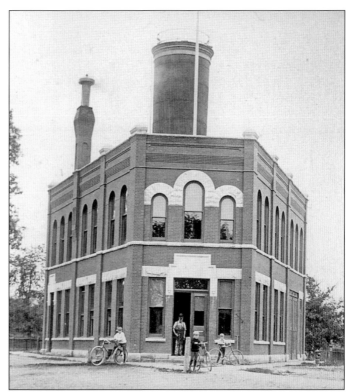

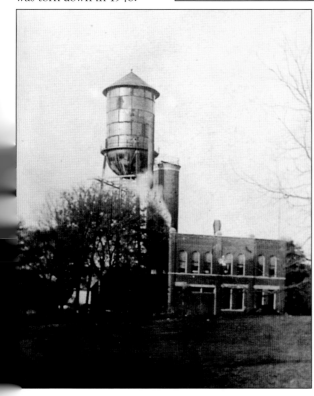

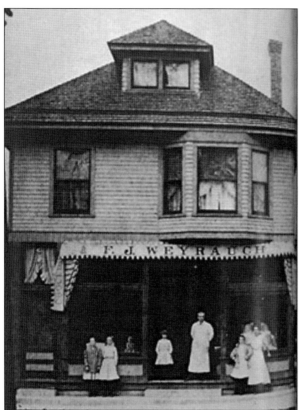

This is the Weyrauch grocery store as it looked around 1900. Located at 147 Vine Avenue, it stood well into the 20th century, where, after an extensive face-lift, it was home to Bob Rowe's Pipe Shop as late as the mid-1990s.

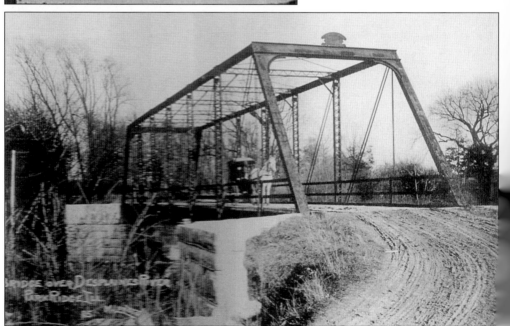

Getting across the Des Plaines River required bridges, but the early wooden structures were subject to washouts during periodic flooding. The first steel bridge at Touhy Avenue solved the problem until a wider span was required with the rise of the automobile.

In the 1870s, pioneer real estate developer Leonard Hodges donated a tract of land between Vine and Courtland Avenues, just south of Prospect Avenue, for the public park that still bears his name. At right stands the new Congregational church on land that he also donated. (Courtesy of Brian Lazzaro.)

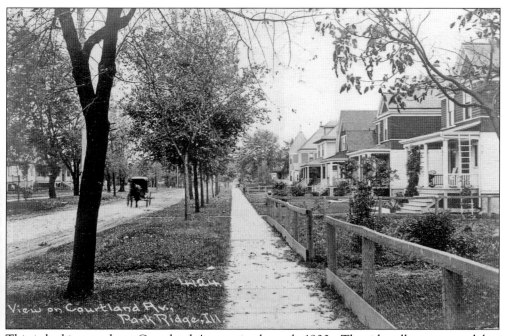

This is looking south on Courtland Avenue in the early 1900s. The sidewalks were paved, but there was not much urgency to pave the streets until the automobile began to phase out the horse and buggy. (Courtesy of Brian Lazzaro.)

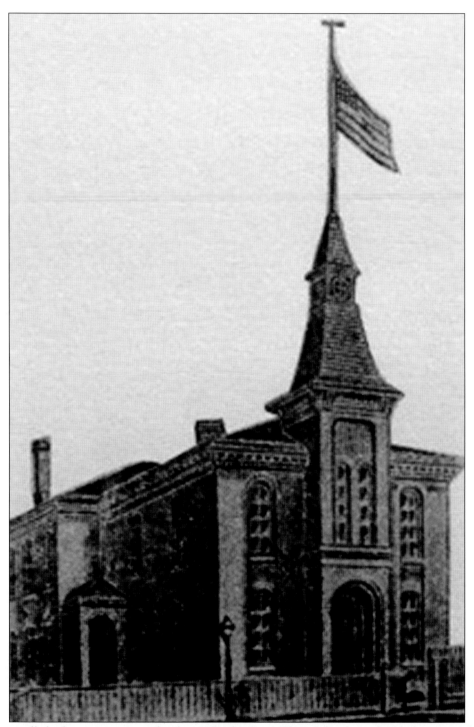

Originally built as a two-room school in 1870, the Grant Place School was doubled in size. After the Central School was built in 1893, it was again expanded, served for a time as a high school, was condemned, and then reopened following the Central School fire in 1830. It stood on what is now the Methodist church parking lot.

With the lack of effective artificial lighting at the end of the 19th century, class pictures were taken in front of the school. This apparently multigrade class picture was taken at Grant Place School in 1870. (Courtesy of the Park Ridge Historical Society.)

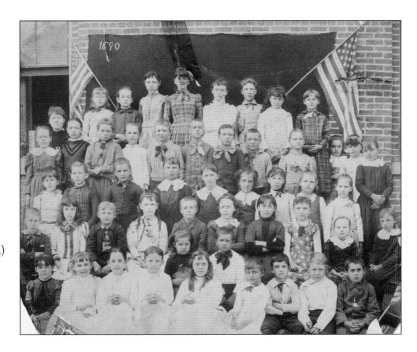

It is summertime, and the living is easy for a half-dozen youngsters at play under the watchful eye of Mrs. John Sunderman, seated on her porch at 500 Leonard Street. (Author's collection.)

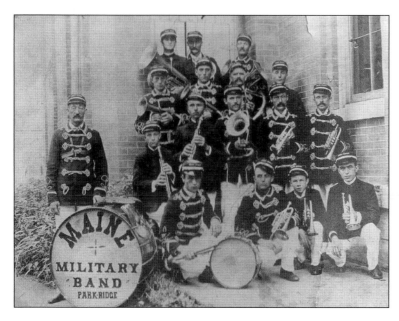

In an era before service clubs and country clubs, military bands were as much social groups as an opportunity make music with like-minded musicians. A fringe benefit was putting on a display in the frequent band concerts and patriotic parades.

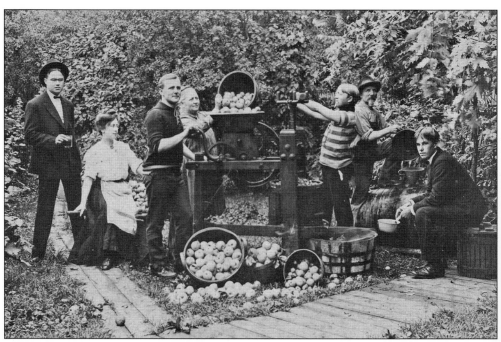

Nothing says fall like some hot, fresh apple cider, and the Ferman family was a primary source for the seasonal staple. They operated this apple press from their home on the northeast corner of Grand Boulevard and Cedar Street in the 1890s. (Courtesy of the Park Ridge Historical Society.)

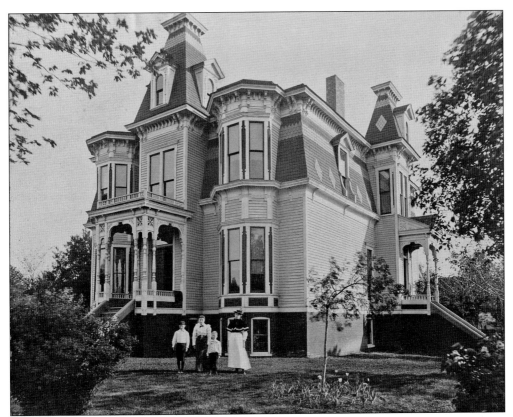

Believed to have been built in 1870, the Aaron Cochran mansion dominated the southwest corner of Fairview Avenue and Main Street. It was destroyed by a spectacular fire that could be seen as far away as Edison Park on Easter morning in 1910. (Courtesy of the Park Ridge Historical Society.)

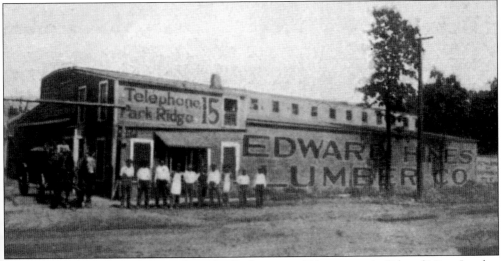

Looking out their second-floor windows, the Cochrans would have seen the Edward Hines Lumber yard just across the tracks and a couple of blocks north. The site would later be developed as the Park Ridge Inn, later transformed into The Summit. Note the spur at lower left that once serviced Charles Penny's brick-making operation.

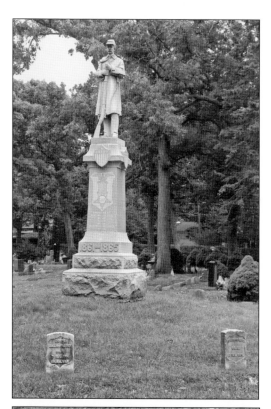

The Civil War was over but not forgotten when this monument was donated by the Women's Relief Corps No. 124 of Des Plaines in the name of the Grand Army of the Republic. Located in the southern half of the Town of Maine Cemetery, it also marks the last resting place of World War II Marine sergeant Donald Shaull, who lost his life on May 2, 1942. (All author's collection.)

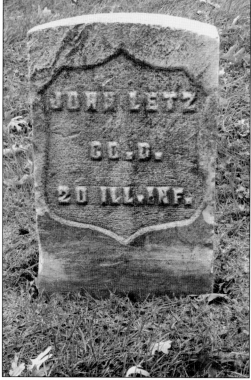

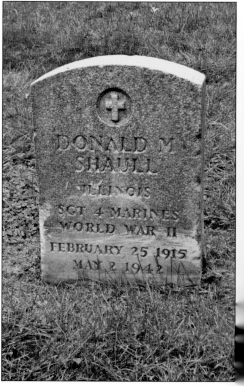

Three

FROM VILLAGE TO CITY

By 1910, there was a growing concern throughout the village that it could lose its identity as an independent community. Chicago had been expanding in all directions by absorbing surrounding villages, including Jefferson Park in 1889 and Norwood Park in 1893. In 1910, Edison Park voted for annexation to Chicago with the promise of expanded municipal services.

But the concept of big-city government was unappealing to most of the village's 2,000 residents who voted to reincorporate as the City of Park Ridge, technically putting itself on an equal footing with Chicago. On May 24, 1910, about 410 voters turned out to choose between Dr. Albert J. Buchheit and William Malone as the city's first mayor. Buchheit won, but Malone came back two years later to capture the post.

By this time, Fred I. Gillick had already established his real estate business and had built a small office building at Main Street and Prospect Avenue, just south of the Ridge Hotel. In 1913, Gillick bought and razed the hotel in order to expand his original building.

Dr. Buchheit was another early builder, constructing a one-story brick building on Vine Avenue across from Hodges Park. He would later add a second story and, not long after George L. Scharringhausen took over Winter's Drugstore in 1924, he would expand the ground floor with an ice cream parlor.

Just south of Buchheit's building, the 1,000-seat Ridge Theater opened in 1926, only to be rivaled by the 1,600-seat Pickwick Theater that opened two years later. More than simply a theater, the Vine Avenue building provided retail space for Henry J. Moheiser's start-up lingerie and hosiery business.

With their eyes on the future, Joseph Novak and Robert Parker opened their electric shop on Main Street in 1915. Because few household appliances were readily available—or even invented as of yet—they spent most of their time wiring homes for electricity.

As the business community expanded, Prospect Avenue began to take on its currently recognizable appearance with commercial buildings inching northward, anchored at Summit Avenue by Charles Stebbings's general store. Farther up the block, Robinson's Soda Shop sold ice cream, sandwiches, cigars, and homemade candy.

Like a teenage growth spurt, Park Ridge was rapidly filling out.

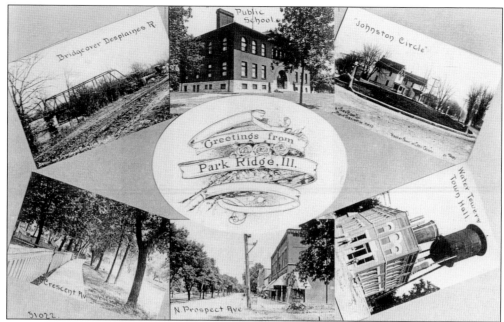

An early postcard pulled out all stops in promoting the young city by featuring its most notable vistas, most of which were within a block of one another. (Courtesy of Brian Lazzaro.)

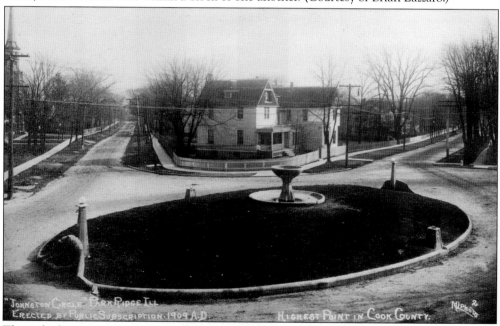

This is looking east on Johnston Circle as it appeared in 1909. Built with funds raised by Mrs. Hester Johnston, it was believed at the time to be the highest point in Cook County. It is not, but the ridge along Prospect Avenue that prompted the city's name is part of a continental divide: water draining to the east flows into the Atlantic by way of the Chicago River and Great Lakes; water draining to the west goes to the Gulf of Mexico via the Des Plaines, Illinois, and Mississippi Rivers. Touhy Avenue is on the left, and the diagonal road on the right is Northwest Highway. The circle survived until 1923. (Courtesy of Brian Lazzaro.)

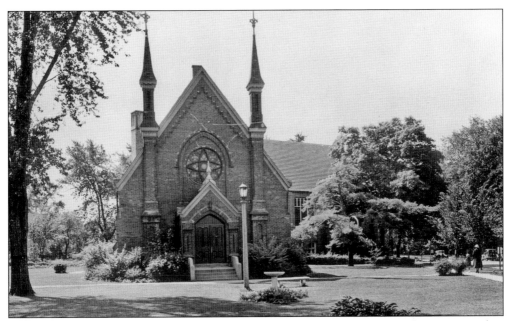

The Park Ridge Community Church traces its roots back to 1843 when it was organized as the Monroe Congregational Church, conducting services in a rude cabin near the Town of Maine Cemetery. In 1874, it was able to build its more appropriate house of worship on land donated by Leonard Hodges at the corner of Prospect and Courtland Avenues. (Courtesy of the Park Ridge Public Library.)

Initially holding services in Electric Hall, St. Mary's Episcopal Church was established as a mission parish in 1895 with a congregation of 45. Its first permanent church was built on the northeast corner of Prospect and Crescent Avenues. (Author's collection.)

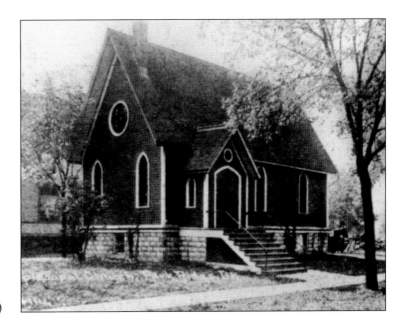

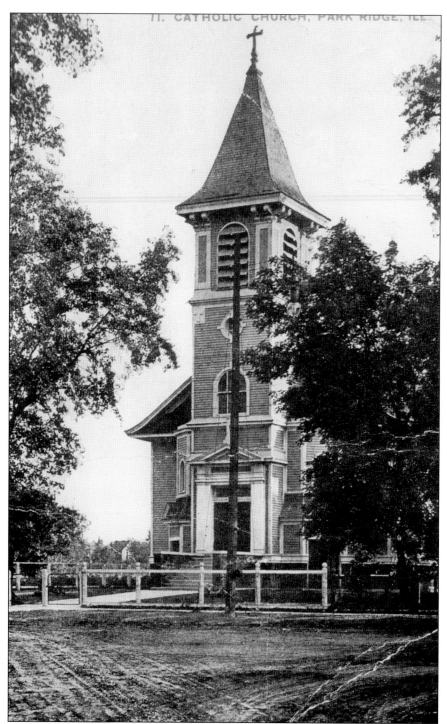

On October 9, 1911, ground was broken on South Northwest Highway for the first Roman Catholic Church to be built in Park Ridge. The patron saint selected for the new parish was St. Paul of the Cross, founder of the Passionist Order in the 18th century. The church was replaced with the present building in 1953. (Author's collection.)

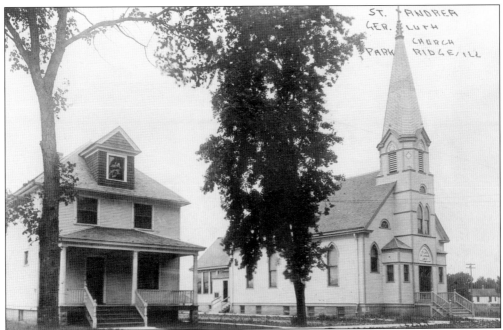

Established in June 1909, the congregation of St. Andrews Evangelical Lutheran Church initially held services in the Grant Place School until able to move into its own home at Northwest Highway and Elm Street. The lot was acquired in 1910 for $1,500, with the new church dedicated on September 17, 1911. (Courtesy of the Park Ridge Historical Society.)

An early postcard boosting the newly reincorporated city was the product of The Colony Crafts, a Park Ridge studio created in 1910 by local artists Dulah Krehbiel and Beulah Clute. In addition to postcards, the studio cranked out greeting cards, calendars, and bookplates. (Courtesy of Herb Zuegel.)

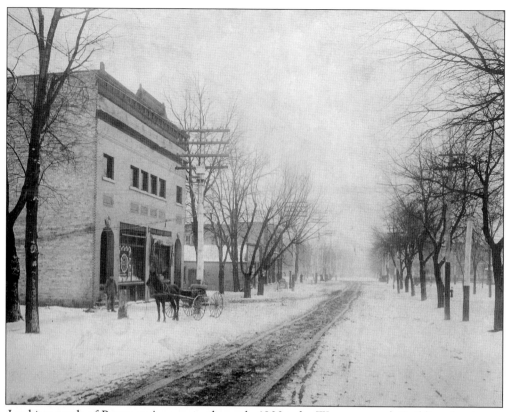

Looking south of Prospect Avenue in the early 1900s, the Wannenwetsch Building dominates the evolving cityscape. The automobile has yet to make its presence felt, and the wagon tracks define a one-lane right-of-way. (Courtesy of the Park Ridge Historical Society.)

By 1910, a new commercial building had been added to the Prospect landscape just south of the Wannenwetsch Building. The Wannenwetsch Building is long gone, but the comparative newcomer, once home to Robinson's Candy Shop, still stands.

An early view of the southeast corner of Prospect and Crescent Avenues shows the transition between the city's wide-open spaces and the development of neighborhoods of single-family homes. (Courtesy of the Park Ridge Historical Society.)

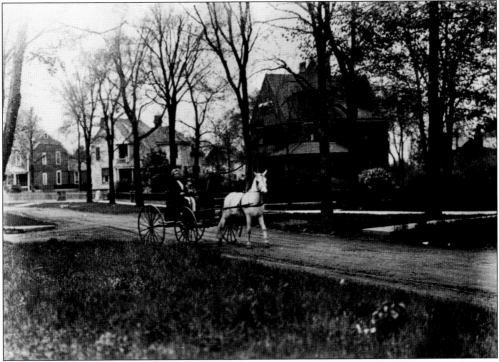

Heading into town from her home at Prospect and Park Plaine Avenues is Mrs. Noyes, the wife of a prominent dentist who focused on the developing practice of orthodontia.

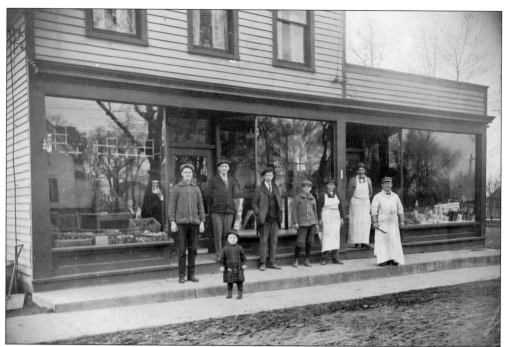

By 1915, Kobow's store had expanded and undergone a face-lift with wall-to-wall windows to entice shoppers inside. The one-story addition to the right housed Eisenhamer Meats (below), featuring Oscar Mayer prepackaged products. (Below, courtesy of the Park Ridge Historical Society.)

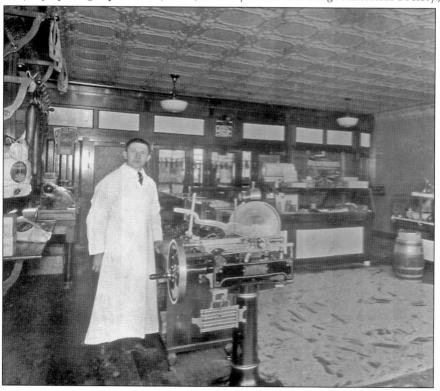

1891.

1891.

Second Annual Catalogue

OF

TROTTING STOCK

AT

Murphy's Stock Farm,

Park Ridge, Ill.,

THIRTEEN MILES FROM CHICAGO, ON THE WISCONSIN DIVISION OF THE CHICAGO & NORTH-WESTERN RAILWAY.

THE PROPERTY OF

JAS. A. MURPHY,

ROOKERY BUILDING,

CHICAGO, ILL.

EVERY ANIMAL IN THIS CATALOGUE IS FOR SALE.

The James Murphy stock farm was located between Belle Plaine Avenue and Talcott Road on Courtland Avenue. It boasted a half-mile track, stud service, and boarding. The fee to board a mare on grass was $1.25 a week or $2.50 if she was fed hay or grain. A staff trainer was available to handle trotters and develop colts. (Courtesy of Brian Lazzaro.)

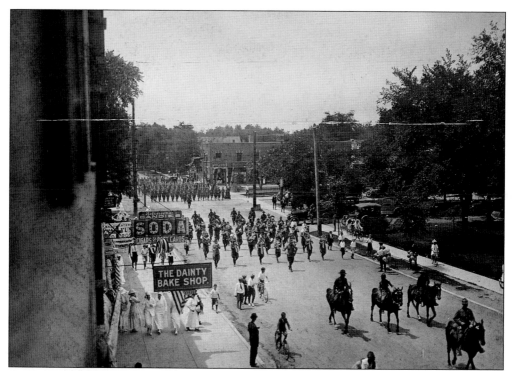

On April 6, 1917, Congress declared war on Germany, joining the conflagration that was raging in Europe. Soon after the United States entered the war, a home guard was organized and, within three months, able to march down Prospect Avenue. At the extreme right in the photograph below is the Carnegie Library building, which still stands at Prospect Avenue and Northwest Highway. (Both author's collection.)

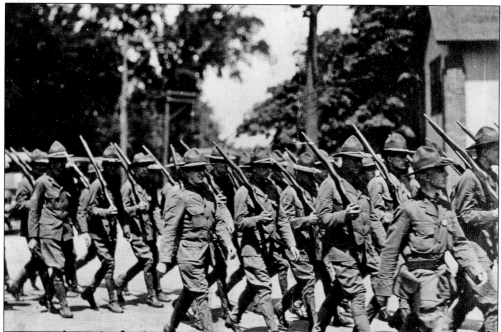

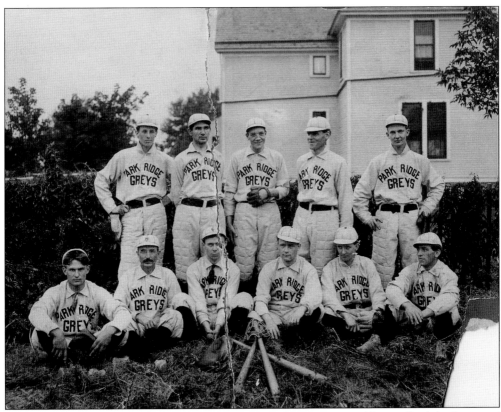

With only 11 players on the team in 1900, the Park Ridge Greys could not afford the luxury of resting pitchers between games. Note the padding on the trousers and the flimsy fielder's mitt on the hand of the man standing in the center. (Courtesy of the Park Ridge Historical Society.)

Little-league baseball was off in the future, but these youngster may have harbored the same dreams to one day make it to the majors like, perhaps, the Park Ridge Greys.

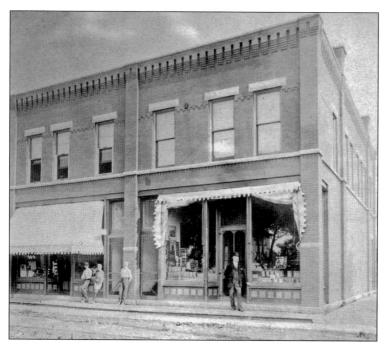

Although originally occupied by Charles Stebbings when he moved his general store from Northwest Highway, it was popularly known as the Stagg Building after Fred Stagg bought the Stebbings business. Still standing after some face-lifts at Prospect and Summit Avenues, it subsequently housed the People's and Merchants Bank, a Walgreens, and most recently a men's clothier.

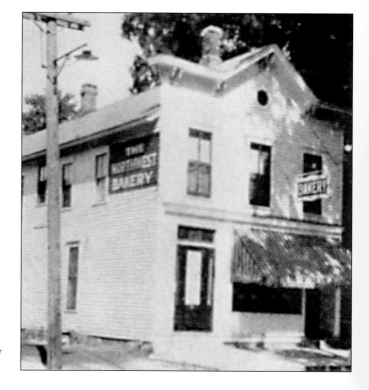

An early transplant from Chicago once asked the delivery boy from Kobow's grocery if she could order some bread. "Around here, everybody bakes their own" was the lad's reply. That was to change with the opening of Wilshek's bakery on Northwest Highway.

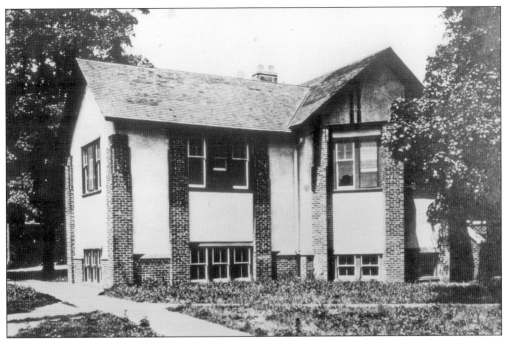

The first regular library board meeting was held on June 10, 1910, and the first order of business was to apply to the Andrew Carnegie Foundation for a grant to build a new library. An initial grant of $5,000 was upped to $7,500, and this building was erected on donated land at Prospect Avenue and Northwest Highway. (Courtesy of the Park Ridge Public Library.)

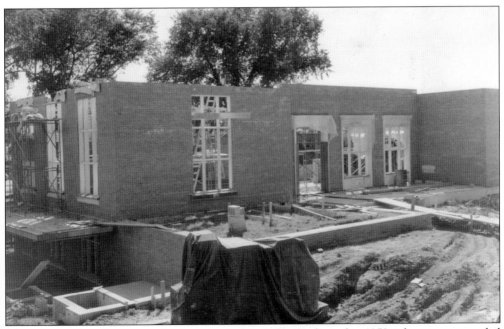

The present library begins to take shape in the late 1950s. Dedicated in 1958, it has since expanded several times in both size and services. (Courtesy of the Park Ridge Public Library.)

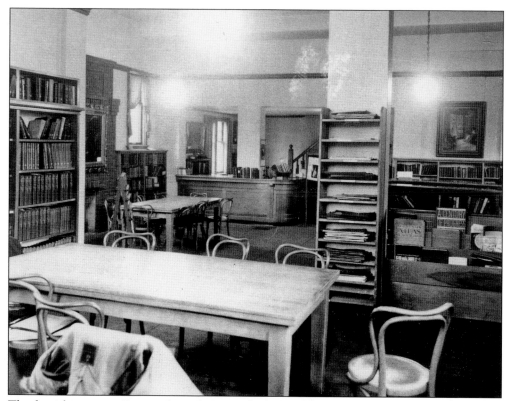

The furnishings were Spartan by today's standards, but the well-lighted adult reading room in the new Carnegie-funded library (above) provided a quiet haven to get lost in a good book or the latest newspaper. The children's reading room (below) featured a round table for youngsters to spread out the books. (Both courtesy of the Park Ridge Public Library.)

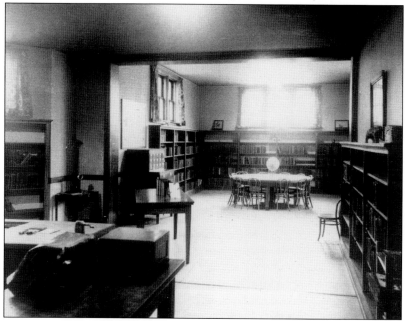

Four

OUT OF THE SMOKE ZONE

Early in his career as a real estate entrepreneur, Fred I. Gillick was credited with having coined the slogan, "Out of the smoke zone; into the ozone." Nothing could have better defined the young city's blueprint for its future development.

Industry and its attendant smokestacks were banned from the city as were, for a time, multifamily housing units. Park Ridge was to be a community of homes and modest businesses to supply the necessary goods and services to its growing population.

Providing the canvas for this utopian goal were, along with Gillick, such business and community leaders as Dr. Albert Buchheit, William Malone, Henry J. Moheiser, George Scharringhausen Sr., Jon Bachmann, Michael Schiessle, and Oscar Carlson. In 1923, Ernst Busse opened his Buick agency in a new 20,000-square-foot building on Northwest Highway (then called Park Avenue) with 45 employees. He was joined two years later by J. W. Burkitt, who had landed the exclusive Cadillac and LaSalle franchise.

The Park Ridge State Bank had moved to a neoclassic brick building at the corner of Prospect Avenue and Northwest Highway in 1914. It was later joined by the Peoples and Merchants Bank in the former Stebbings store at Prospect and Summit Avenues.

Residential and commercial subdivisions began to blanket the area surrounding the six-corner intersection at Johnston's Circle. William Malone built a commercial strip along the east side of North Northwest Highway between Prospect and Meacham Avenues. And Swedish immigrant Edward Bjork built 80 single-family homes along with the Talcott Manor apartment building in just six years.

Supplying the raw materials for these ambitious building projects was the Edward Hines Lumber Company at Touhy and Meacham Avenues, later the site of the Park Ridge Inn. Some homes, however, arrived in boxcars when, in 1908, Sears Roebuck offered complete kits with all the parts needed to assemble a house. Twenty-two styles were available, ranging in price from $650 to $2,500.

Adding to the city's gentrification, a new public library, built with a grant from the Carnegie Foundation, opened on the corner of Prospect Avenue and Northwest Highway in 1910. The Park Ridge Tennis Club listed hundreds of members and, in 1906, H. J. Tweedie mapped out a new nine-hole golf course on the Robb farm west of Prospect. More than 100 years later, it survives as the 18-hole Park Ridge Country Club.

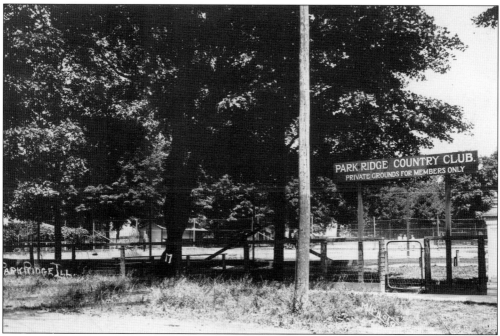

The Park Ridge Country Club traces its modest beginnings to a private tennis club with five courts located on the east side of Northwest Highway at Summit Avenue. In 1906, its members decided to seek room for the "physically less punishing game of golf." (Courtesy of the Park Ridge Country Club.)

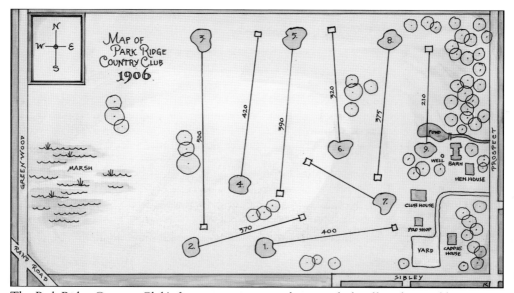

The Park Ridge Country Club's first course was a modest nine-hole affair, designed by amateur golfer H. J. Tweedie. Although the acreage of the former Robb farm would have accommodated an 18-hole course, the norm at the turn of the 20th century tended to favor long holes. The exact design is unknown, but it probably closely resembled this illustration. (Courtesy of Bernie Roer.)

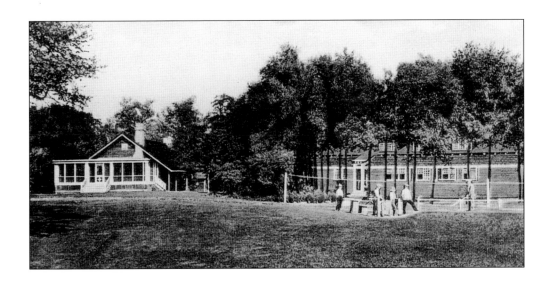

The Robb farmhouse served as clubhouse during the Park Ridge Country Club's formative years, but by 1912 it was clear that more space was needed. Architect Frank Lloyd Wright's plan (below) added wings north and south. The expanded clubhouse was replaced with the existing structure in the mid-1920s. (Both courtesy of the Park Ridge Country Club.)

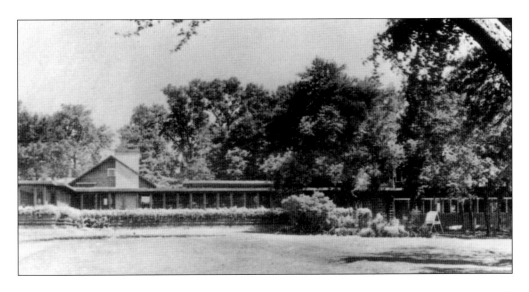

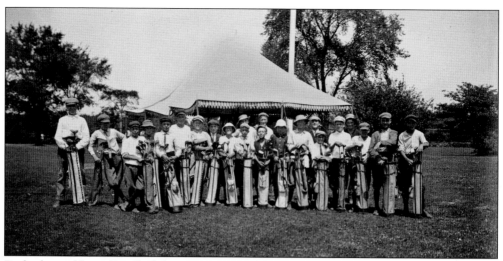

Back when golfers still walked the course, many club members opted to have young men and boys carry their bags and follow the flight of the ball. More experienced caddies often offered tips on club selection to the less experienced duffers. (Courtesy of the Park Ridge Country Club.)

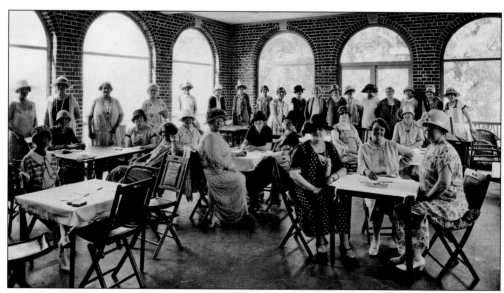

There is more to country club membership than access to neatly groomed fairways for a bracing round of golf. Here the "golf widows" of the late 1920s meet to gossip and, incidentally, play some hands of bridge. (Courtesy of the Park Ridge Country Club.)

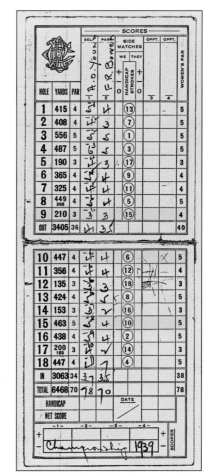

In 1939, a diminutive Ray Bowen, at 5 feet, 4 inches and 140 pounds, bested all-time club champion A. O. Young for the title by scoring a par 70 to Young's 78. Though never again a scratch golfer after contracting polio in 1943, he continued to play the game—with the help of a golf cart after 1960—until turning 80 years old in 1987. (Both courtesy of the Park Ridge Country Club.)

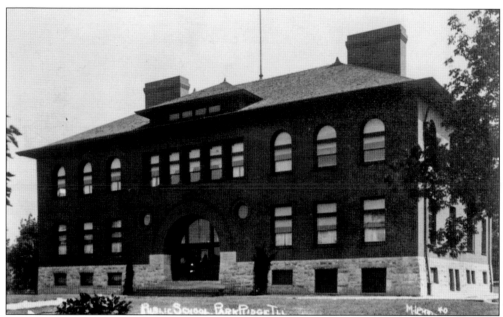

In 1893, the eight-room Central School was built to replace the increasingly cramped Grant Place School. Facing Summit Avenue, it was built on land purchased from Blacksmith Miller, now the site of the Park Ridge Public Library. The cost of the 4-acre lot was $1,000 with the construction cost adding another $19,500. (Author's collection.)

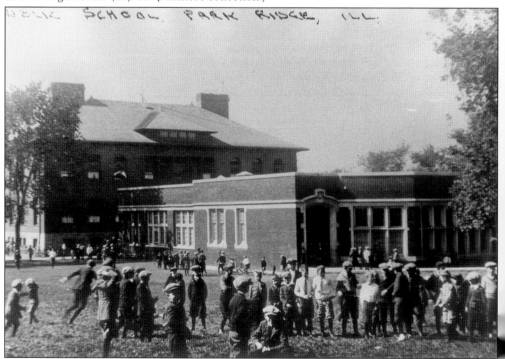

It was not long before a growing population forced the expansion of Central School. In this undated photograph, the one-story addition stretches east toward Prospect Avenue. (Courtesy of the Park Ridge Public Library.)

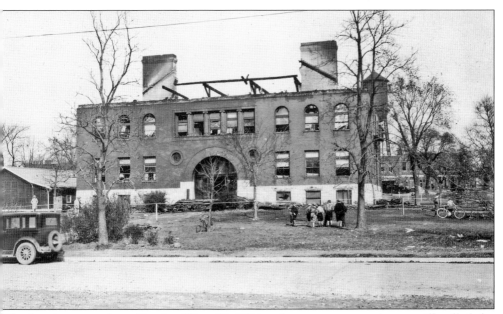

Whether it occurred on October 30 or 31, 1930—the sources vary—it was still called the "Halloween Fire," which totally destroyed the Central School. In its aftermath, classes were shifted to the cramped Grant Place School despite its having been previously condemned. (Courtesy of Don Pfister.)

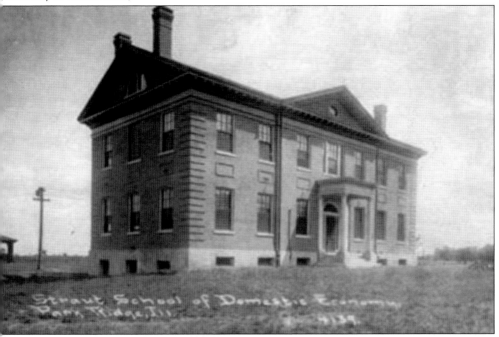

More fortunate than the ill-fated Central School, the administration building of the Park Ridge Youth Campus has survived into the 21st century. Originally established as the Illinois Industrial School for Girls, it was renamed the Park Ridge School for Girls after moving to a 40-acre tract east of Prospect Avenue just south of Oakton Street in 1908. Among its early directors was Hull House founder Jane Addams.

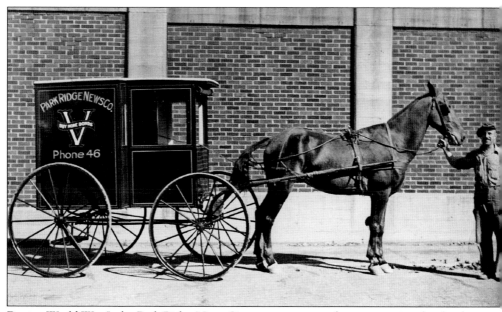

During World War I, the Park Ridge News Company was a one-horse operation, but by the time of World War II, the staff had expanded considerably with its headquarters in the Ridge Theater Building. One thing—the phone number—remained unchanged at 46. (Both courtesy of the Park Ridge Historical Society.)

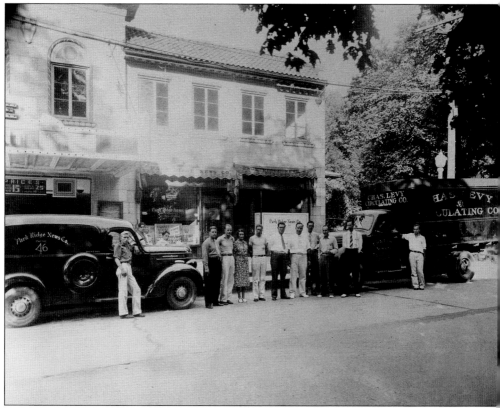

Amilie Maas poses in front of her home at 310 Grand Boulevard sometime in the mid-1920s. Built virtually on the edge of Penny's clay pits in 1856, the home still stands with minor alterations (below) and is one of the oldest homes in Park Ridge. (Above, author's collection; below, A Sterling Design.)

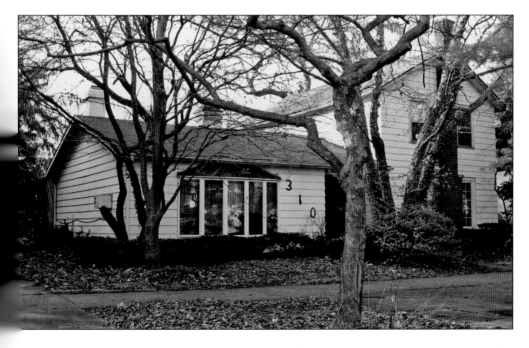

Along with Fred I. Gillick and William Malone, Mike Schiessle was an early force in Park Ridge development. In addition to managing his real estate and insurance interests, he served as a justice of the peace, township collector, and managed the city's first electric distribution system, which he later sold to the North Shore Electric Company. He also served two years as city treasurer, rebating interest earned on city funds to the taxpayers.

In 1929, Mike Schiessle could put a family in a five-room brick bungalow with a fireplace and hot water heat for just $15,500. A frame bungalow sold for just $8,500 according to this ad from the *Park Ridge Weekly*.

An economical alternative to a fully equipped brick bungalow was to order an unassembled home from the Sears Roebuck catalog. Precut lumber, fixtures, and plans—everything needed to put the house together—arrived in a boxcar. Twenty-two styles were available in the 1908 catalog, including the Dutch Colonial (above) at 231 North Washington Avenue and the craftsman style (below) at 730 South Washington Avenue. Prices ranged from $650 to $2,500. (Both courtesy of A Sterling Design.)

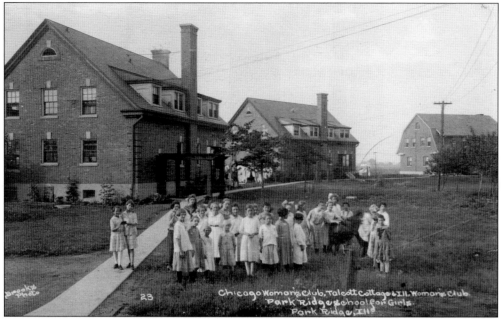

Now known as the Youth Campus, the Park Ridge School for Girls was a safe haven for orphaned and troubled girls. Established in Park Ridge on a 40-acre tract on North Prospect Avenue in 1909, the school was founded 32 years earlier in Evanston. In this 1922 view, students pose in front of three of the donated cottages that housed them. (Courtesy of Brian Lazzaro.)

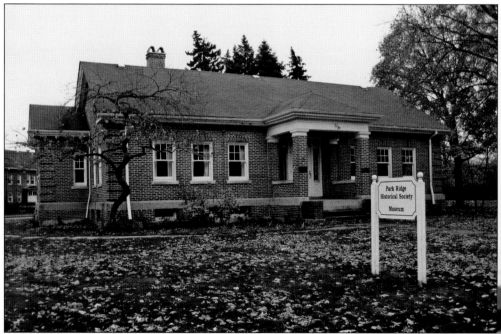

The Soloman Cottage at the southwest corner of the Youth Campus has been selected as the third and latest home of the Park Ridge Historical Society Museum. The first was located in the former Fred I. Gillick home at Euclid and Summit Avenues, which was subsequently razed to open the way for commercial development. (Courtesy of the Park Ridge Historical Society.)

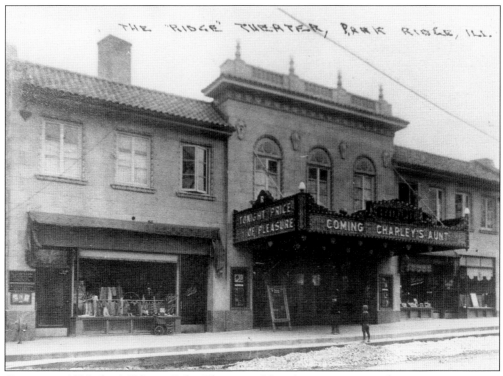

Opening in 1926, the 1,000-seat Ridge Theater on Vine Avenue was more than an entertainment venue. It provided space for the start-up Moheiser hosiery business and for Von Buelow's silversmiths and watchmakers. Soon eclipsed by the larger Pickwick Theater, it was purchased by Pickwick developer William Malone and stood empty for years before being converted in 1959 into Michael Kirby's ice-skating school. It was torn down in the 1970s to clear the land for present condominiums.

Across the street from the Ridge Theater was the stone four-flat to the right in this view looking south on Vine Avenue. The building was razed to clear the land for the city hall parking lot.

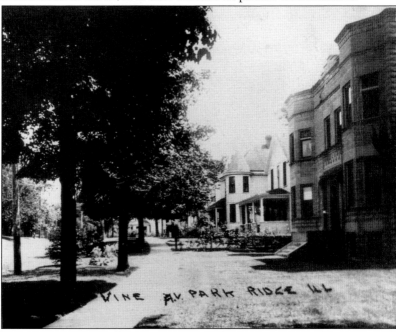

An early tenant of Fred I. Gillick's new building at Main Street and Prospect Avenue was Dr. Albert Buchheit, a dentist who also served a two-year term as the city's first mayor. He later built the one-story brick building—subsequently expanded upward and outward—that bears his name on Vine Avenue, just south of Prospect Avenue.

As mayor, banker, and developer, William C. Malone has left a lasting mark on the city with the Pickwick Building and a commercial strip on Northwest Highway as enduring elements of his legacy. A vocal advocate in the drive to switch from a village to city form of government, he later negotiated as mayor with the City of Chicago to buy its Lake Michigan water for 7¢ per 1,000 gallons.

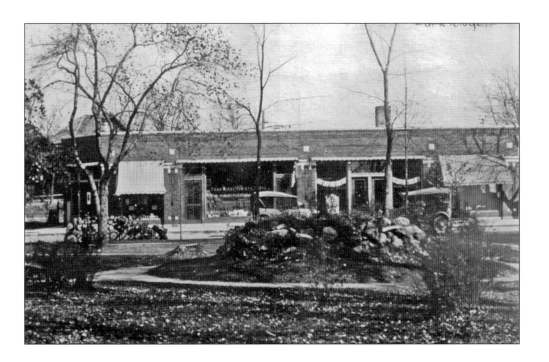

It was originally a one-story building, but sometime in the early 1920s, Dr. Albert Buchheit added a second story to house his dental practice, freeing up the first floor for retail stores. After George L. Scharringhausen Sr. bought out Winter's Drugstore, an addition to the first floor (below, at left) housed Scharringhausen's soda fountain.

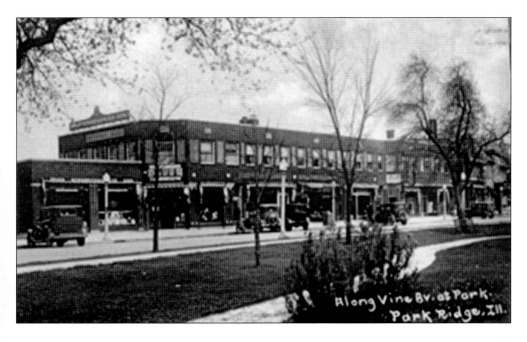

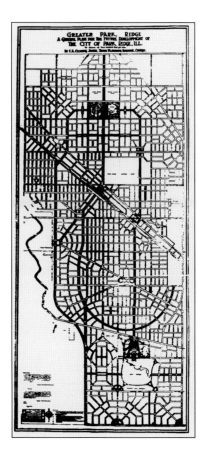

By the early 1920s, the city fathers were looking ambitiously beyond its present boundaries, drafting a plan that would extend its borders to Ballard Road on the north and Foster Avenue on the south. The area bounded by Higgins, Cumberland, Canfield, and Foster (below) was to be developed as a public park and golf course.

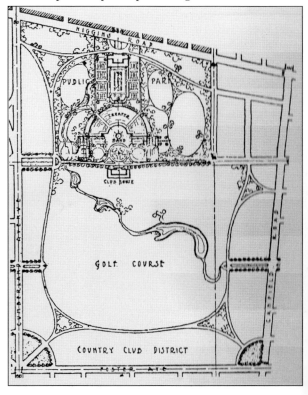

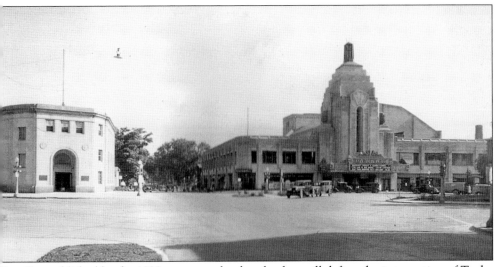

Equally established by the 1930s were two landmarks that still define the intersection of Touhy and Prospect Avenues and Northwest Highway. While the Pickwick Building remains essentially unchanged, what was then the Citizens Bank has since undergone a massive face-lift. The city's signature landmark in the Pickwick Building dominated the corner of Prospect Avenue and South Northwest Highway. Developed by William Malone, the Pickwick was designed by the architectural firm of Zook and McCaughey. It seated 1,600 patrons at the time and was equipped to handle Vitaphone and Movietone films. The cast-iron lantern topping the tower was designed to brighten the night sky with flashing colored lights.

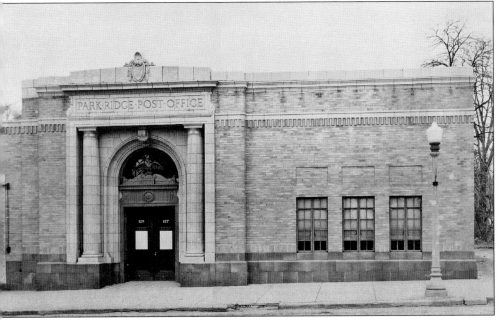

Probably no public agency has had a more nomadic existence than the Park Ridge Post Office, having hopscotched across town from Talcott's cabin in the 1840s to its present location at Busse Highway and Elm Street. Here it paused in the late 1920s on the east end of the Malone block on North Northwest Highway. Its later uses included a funeral parlor and flower shop. (Courtesy of the Park Ridge Historical Society.)

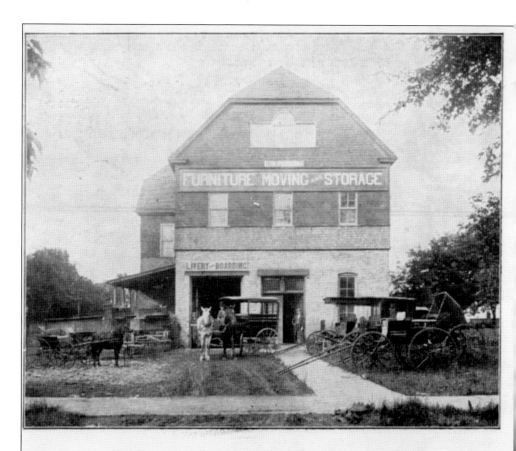

Perkins' Express

LEWIS D. PERKINS

Packing **Moving** **Storage**

Express service daily, covering all parts of the city and suburbs.

Reduced freight rates on household goods to Western and Southern points.

The ONLY STORAGE WAREHOUSE in the Northwest suburbs.

Twenty years' experience in the moving business.

Auto and Horse Livery

Office and Warehouse:
29-31 Main St., Park Ridge, Ill.
Tel. 25

Chicago Office:
123 N. Market St.
Tel. Main 779

A 1916 advertisement for Lewis Perkins' Express company offers a variety of services from furniture moving and storage to livery and boarding. Located in the former Electric Hall, it held a virtual monopoly on the public storage business.

After less than five years of sharing space with the Gillick real estate office, it was clear that the Park Ridge State Bank needed a home of its own. Built where the Pickwick Building now stands, the bank's new facility opened for business on September 12, 1914. (Courtesy of Fred Gillick.)

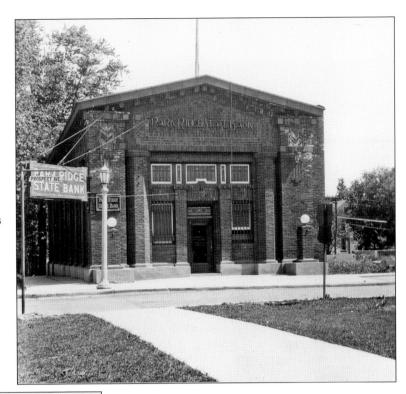

Financial Statement

AS OF APRIL 10, 1923

RESOURCES

Loans and Discounts	$ 501,608.32
U.S. Government Investments	8,500.00
Other Bonds	275,584.64
Bank Building	25,825.00
Furniture and Fixtures	232.85
Due from Banks, Cash and Other Cash Resources	277,688.25
Other Resources	1,032.71
Total	
	$1,090,502.07

LIABILITIES

Capital Stock	$ 50,000.00
Surplus and Undivided Profits	23,035.40
Deposits	1,017,466.67
	$1,090,502.07

With a balance sheet topping $1 million, the Park Ridge State Bank showed a healthy financial picture in 1923. Note that its furniture and fixtures were assessed at just $232.85, about the price of a single teller's chair today. (Courtesy of Fred Gillick.)

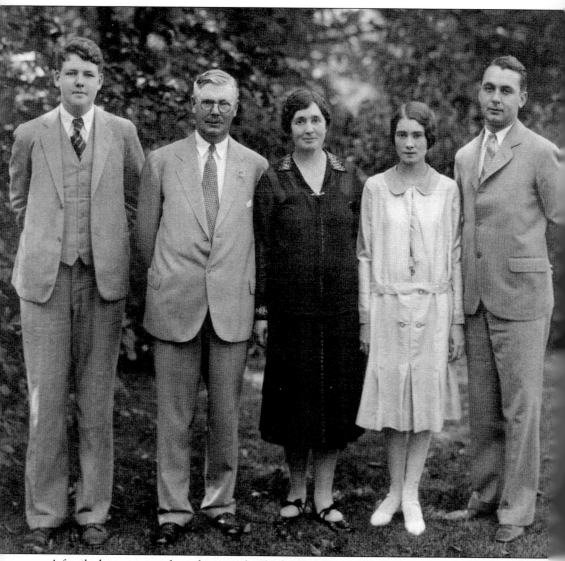

A family dynasty poses for a photograph. Flanking Fred I. Gillick (second from left) are sons John (far left) and Irving (right), wife Marian, and daughter Helen. John continued to run the real estate business and Irving was instrumental in founding Park Ridge Federal Savings and Loan. (Courtesy of Fred Gillick.)

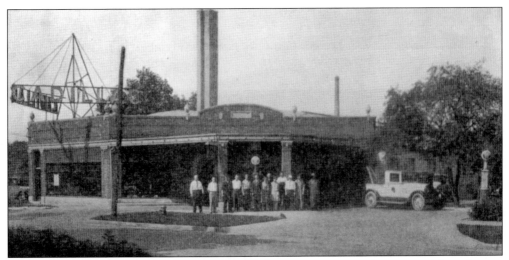

In the mid-1920s, John W. Burkitt decided to offer his customers more than grease jobs and tune-ups at his service station by successfully landing a Cadillac and LaSalle franchise. After serving in World War I, he briefly ran an open-air repair facility behind Robinson's Candy Store before building this garage near Meacham Avenue and Northwest Highway in 1925.

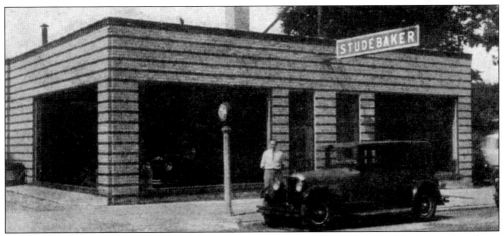

Adding to the motorist's choice when selecting a new car were the Studebaker and Erskine lines offered by Park Avenue Motor Sales. The short-lived Erskine was produced from 1926 to 1930 and sold for $995 but was doomed when Ford's comparable Model A was introduced in 1927 for just $525.

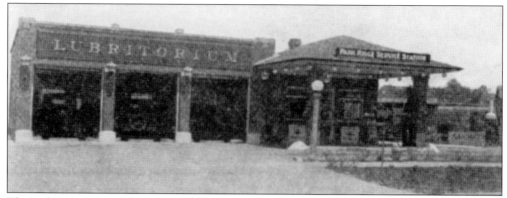

The Park Ridge Service Station on Touhy Avenue at Third Street offered a three-bay "lubritorium" to keep those early Fords, Packards, Studebakers, and Auburns running smoothly and squeak-free while bouncing over the early roads' potholes.

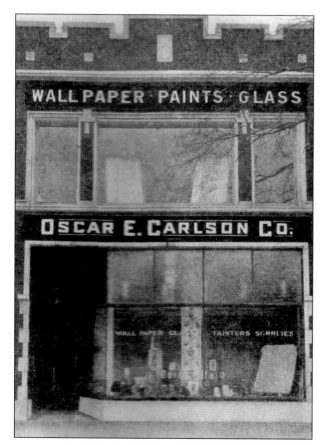

Oscar E. Carlson had already operated several paint and wallpaper stores throughout the Chicago area since 1907 when he opened a Park Ridge branch in 1923, later expanding into a new two-story building that he built on Main Street in 1927.

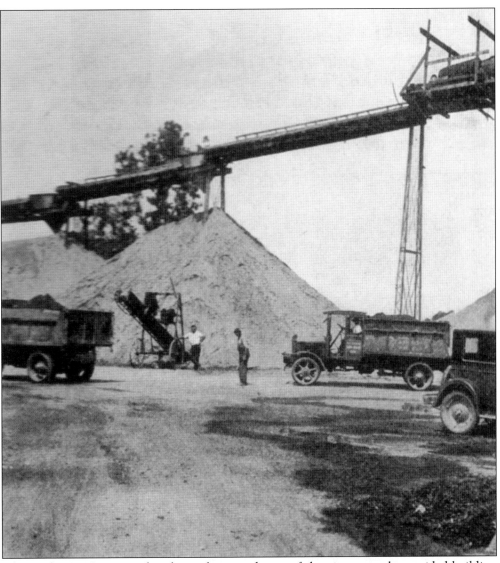

John Reding's 16-acre sand and gravel pit southwest of the city not only provided building materials for the Pickwick Building, but it also left a scenic fishing hole known today as Axehead Lake. A similar mining operation by Fred Fricke near Touhy Avenue and Dee Road created Murphy and Park Lakes.

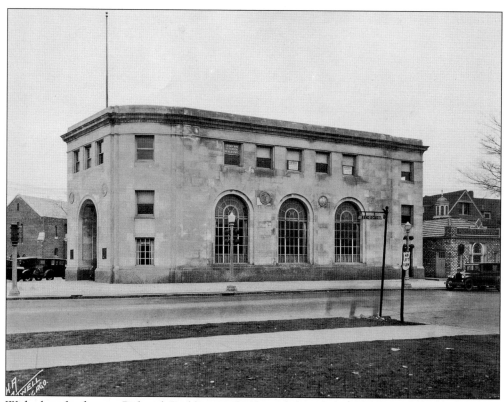

With plans for the new Pickwick Building on the drawing board, the Park Ridge State Bank moved across the street to this new two-story building in 1926. Its former home was moved one block south on Northwest Highway. In 1929, the bank changed its name to Citizens Bank. (Courtesy of the Park Ridge Historical Society.)

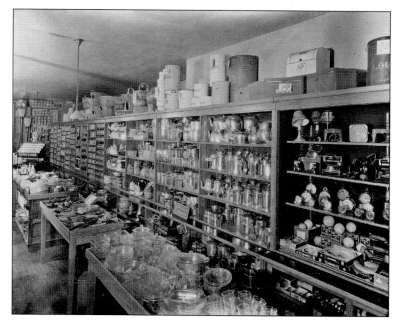

Its shelves well stocked with clocks, teapots, and baseballs, Roloff's Hardware at Summit Avenue and Northwest Highway was the city's first Ace franchise. The building was razed in the 1950s. (Courtesy of the Park Ridge Historical Society.)

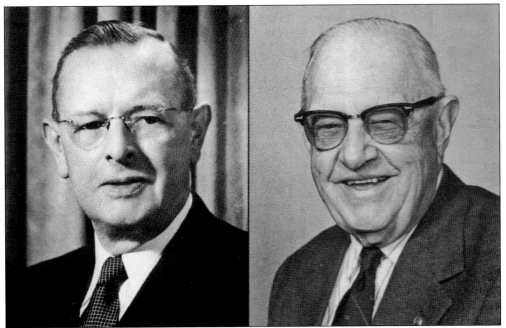

George L. Scharringhausen Sr., (left) and son George Jr. (right) were more than successful retailers; both were heavy contributors to the city's service and charitable activities. They were active in the Park Ridge Kiwanis, the Park Ridge Chamber of Commerce, and other community organizations. George Jr. also published Rev. Orvis Jordan's 1961 *History of Park Ridge*.

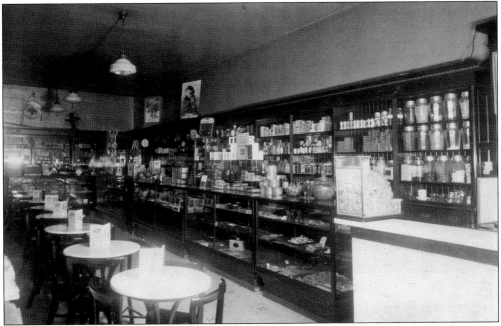

In 1924, George L. Scharringhausen Sr. bought the Winter's Drugstore in the Buchheit Building at 135 Vine Avenue and later expanded the business with this soda fountain. The business was nearly wiped out by the Great Depression but survived by moving into cramped quarters on Main Street. (Courtesy of Bill Scharringhausen.)

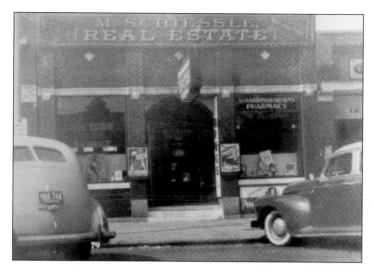

The Great Depression caused many businesses, large and small, to lock their doors forever. Especially hard hit was Scharringhausen Pharmacy, which was forced to close down its soda fountain and consolidate its core business. With financial assistance from the local business community, the pharmacy survived by sharing space in Mike Schiessle's Main Street office.

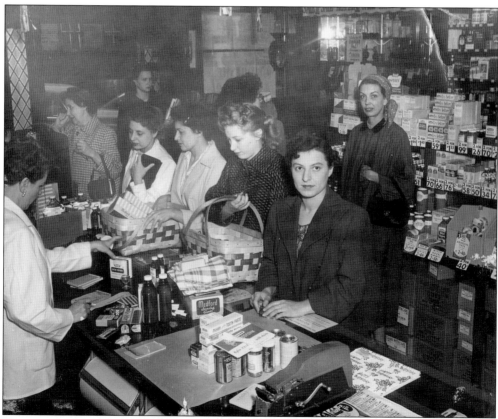

Things were cramped in the half-store that Scharringhausen shared with the Schiessle real estate office, but shoppers remained loyal to the father-and-son team. The soda fountain was a memory, but the pharmaceutical end of the business remained strong. (Courtesy of Bill Scharringhausen.)

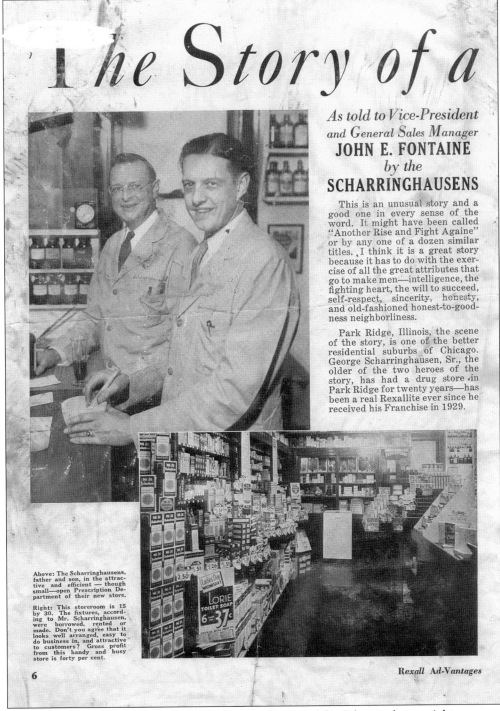

The Story of a

As told to Vice-President and General Sales Manager
JOHN E. FONTAINE
by the
SCHARRINGHAUSENS

This is an unusual story and a good one in every sense of the word. It might have been called "Another Rise and Fight Againe" or by any one of a dozen similar titles. I think it is a great story because it has to do with the exercise of all the great attributes that go to make men—intelligence, the fighting heart, the will to succeed, self-respect, sincerity, honesty, and old-fashioned honest-to-goodness neighborliness.

Park Ridge, Illinois, the scene of the story, is one of the better residential suburbs of Chicago. George Scharringhausen, Sr., the older of the two heroes of the story, has had a drug store in Park Ridge for twenty years—has been a real Rexallite ever since he received his Franchise in 1929.

Above: The Scharringhausens, father and son, in the attractive and efficient — though small—open Prescription Department of their new store.

Right: This storeroom is 15 by 30. The fixtures, according to Mr. Scharringhausen, were borrowed, rented or made. Don't you agree that it looks well arranged, easy to do business in, and attractive to customers? Gross profit from this handy and busy store is forty per cent.

6

Rexall Ad-Vantages

An undated edition of the Rexall Ad-Vantages took note of the Scharringhausens' drive to stay afloat with their regrouping efforts during the Great Depression, citing their "intelligence . . . fighting heart, [and] will to succeed." (Courtesy of Bill Scharringhausen.)

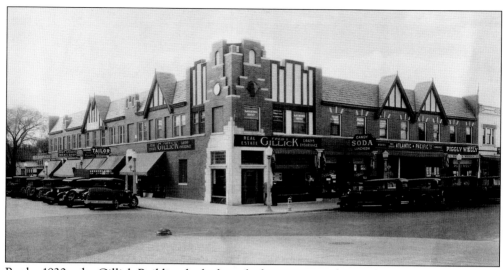

By the 1930s, the Gillick Building looked much the same as it does today; only the tenants are different. Anchoring the west end of the building was Bachmann's Hardware. More intriguing was the proximity of the A&P and Piggly Wiggly, side by side, at the north end of the building. (Courtesy of Fred Gillick.)

In order to compete with the Piggly Wiggly next door in the Gillick Building, the A&P stressed its low prices in this ad in the *Park Ridge Weekly* in 1929. Long gone are Grandma's Washing Powder and Chipso Quick Suds.

After being asked to take a pay cut as a wholesale hosiery manager for Carson's, Henry J. Moheiser struck out on his own in 1926, opening a small lingerie business in the Ridge Theater building. In 1928, he moved the business to the new Pickwick Building, expanding in 1936 with a move to the Gillick Building at 110 South Prospect Avenue. (Courtesy of Rick Cubberly.)

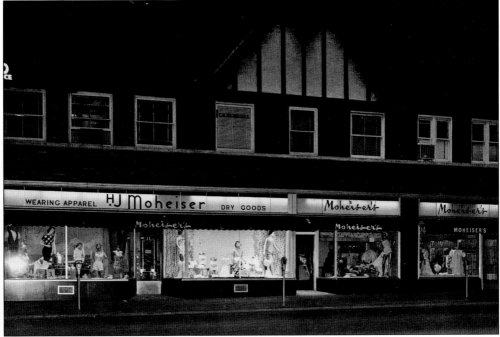

By the 1930s, Moheiser's Department Store settled into its final location on the Prospect Avenue side of the Gillick Building. After the Bachmann Hardware fire in 1940, it expanded to the west, later stretching east into a former shoe repair shop and tailor. (Courtesy of Rick Cubberly.)

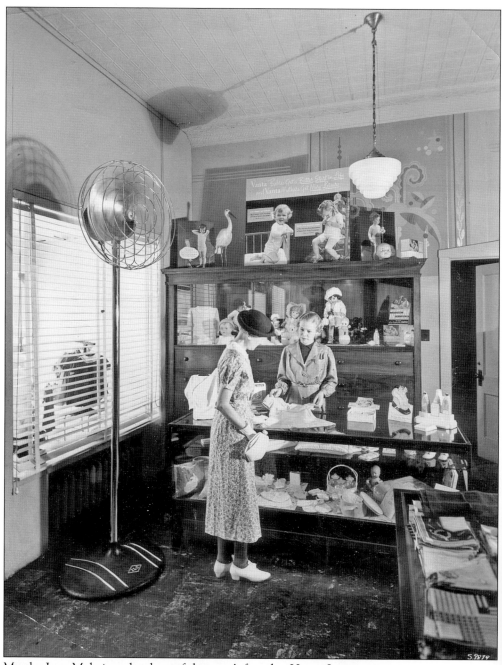

Martha Jean Moheiser, daughter of the store's founder, Henry J., waits on a customer sometime during the 1930s. No longer limited to hosiery and lingerie, Moheiser's offered an eclectic variety of gift items as well. (Courtesy of Rick Cubberly.)

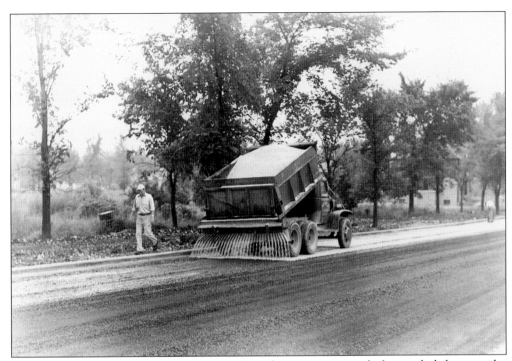

An undated photograph shows the preferred road paving practices before asphalt became the medium of choice. After tarring the surface, a dump truck backs slowly down the road, spreading fine gravel, which bonds with the tar. (Courtesy of the Park Ridge Public Library.)

More than an excuse to unwind with friends and neighbors, this 1922 street dance was staged to celebrate the street itself. Main Street—at last—was paved and Mayor C. H. Tharp was there to preside over the festivities.

In 1901, Maine Township voters approved the establishment of a high school board and the subsequent issue of $15,000 in bonds to fund the construction of a school building. Classes were held in Central School until the new building was ready for occupancy, welcoming 35 students when it opened in November 1902. By 1916, the building had been expanded with a gym, pool, showers, and lockers.

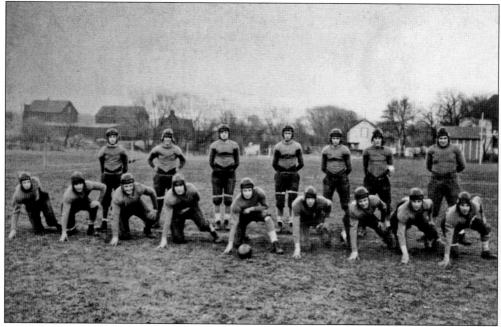

Leather helmets and abundant padding comprised the standard uniform for the 1925 Maine Township High School football team. With only 16 players, a two-platoon system was unthinkable.

First the site of the cabin of Rand Road surveyors Warner and Stevens on North Northwest Highway, this location was later redeveloped with George Penny's brick home—Park Ridge's first—in 1854. After ownership transferred to Capt. William Black, it burned at the end of the 19th century, to be followed by the A. C. Brecken home, and was transformed into the Masonic Temple, shown here in 1924.

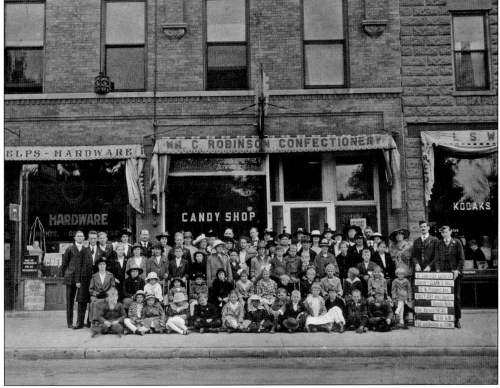

Before St. Luke's Lutheran was able to build its own permanent home at Prospect Avenue and Cedar Street, services were held in Clark's Hall on the second floor above Robinson's Candy Shop at 33 South Prospect Avenue.

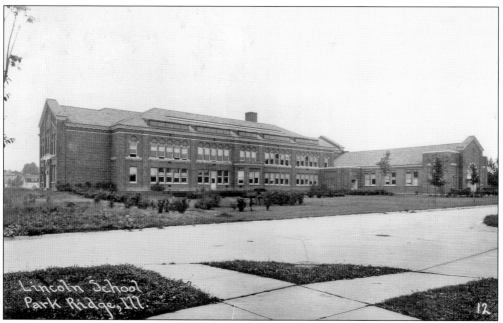

Lincoln School, shown here in 1937, was built to help fill the void after the Central School fire. The future direction of the School District 64 philosophy was to build smaller neighborhood schools that were generally within walking distance of the students. (Courtesy of Brian Lazzaro.)

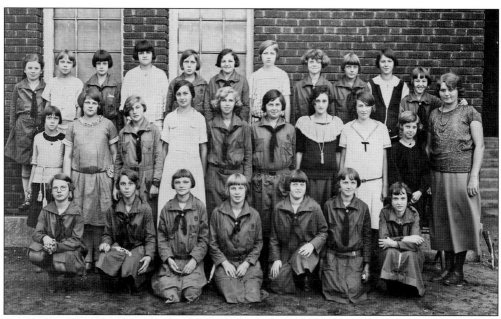

Founded by "Daisy" Low in Savannah, Georgia, with 18 girls in 1912, the Girl Scout movement spread rapidly across the country, capturing local attention within a decade. By 1925, the Park Ridge Girl Scout Troop No. 1 had 28 members. Second from left in the top row is Martha Jean Moheiser, daughter of the department store's founder. (Courtesy of the Park Ridge Historical Society.)

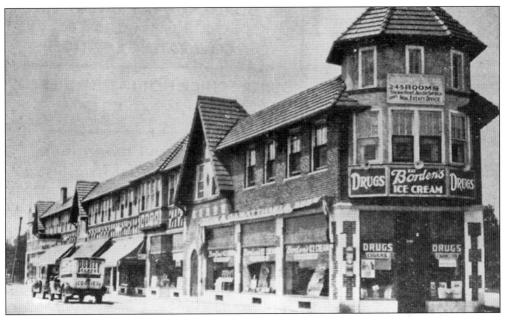

Residential development had moved far enough south by 1931 when this photograph was taken to support a drugstore and other retail shops in the "flatiron building" on the triangle bounded by Devon Avenue, Talcott Road, and Courtland Avenue. Later home to Wieshuber Jewelers, a grain and feed business operated out of the west end of the building as late as the 1960s.

The Park Ridge Tennis Club, located in today's South Park, boasted its own clubhouse, a dozen courts, and about 60 members in the 1930s. Rules were strict, and no one was allowed on the courts unless properly attired in white shirt, slacks, and tennis shoes.

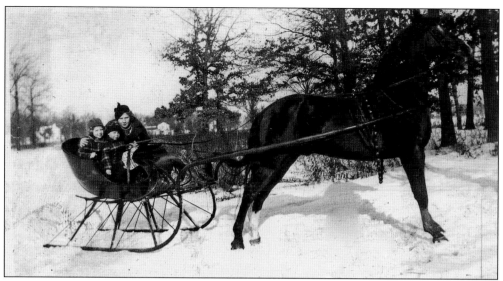

Although the automobile largely replaced the horse and buggy by 1936, the Kainer family still kept a horse at their home at 1304 South Knight Avenue. With Glendora Kainer and her children, Fred and Doris, in the sleigh, Lionel Barrymore strikes a regal equine pose. When not pulling the sleigh, he shared quarters with the family car in the Kainers' two-car garage. (Courtesy of John Kainer.)

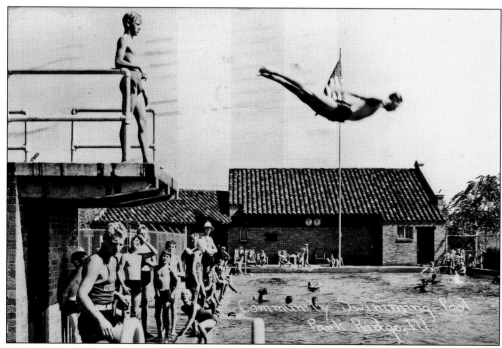

A diver is caught in midair over Hinkley Pool in this 1938 penny postcard. The sender, a visitor named Esther, writes back home to Ohio that "everything up here is a lot of fun." (Courtesy of Brian Lazzaro.)

Five

INTO THE OZONE

By the mid-20th century, the city's image was well established as an upscale "bedroom community." While a large percentage of its breadwinners commuted to Chicago's Loop on the Chicago & North Western Railroad, thousands more were employed locally, notably in the city's several auto dealerships and in the many trade associations that found its housing and proximity to O'Hare Field attractive amenities.

Extensive road improvements had been completed, converting periodic quagmires into all-weather surfaces. Water and sewer lines continued to reach out into ever-expanding neighborhoods. A new library was being built on the site of the former Central School. And, although an ambitious plan adopted by the city council in 1926 that sought to extend the city's boundaries to Ballard Road on the north and to Foster Avenue on the south had been abandoned, its very conception demonstrated the city's confidence in its destiny.

Aside from a few chain stores like Jewel, National Tea, and Woolworth's, most local businesses were family owned and operated. There was Scharringhausen's drugstore in the center of town, Piepho's at Devon Avenue and Talcott Road, and Lampert's Pharmacy near Northwest Highway and Oakton Street. Moheiser's would prove to be the city's first and only department store. Robinson's candy store was a popular snack shop, while The Pantry and Tally Ho restaurants provided more leisurely sit-down meals.

Local civic and service groups organized parades, band concerts, and other public events. A network of neighborhood schools enabled most of the city's youngsters to walk to their classes. Parks were abundant and easily accessible. Several churches served Roman Catholics and a variety of Protestant denominations. On the south edge of the city, a modern expressway—ultimately to be named after Pres. John F. Kennedy—was being built to offer an alternative commute to Chicago and to distant cities.

But in the early 1950s, it became apparent that something important was still lacking. Residents in need of medical treatment had to travel into Chicago or to Evanston to give birth, undergo surgery, or recover from debilitating illnesses or injuries. That was to change in 1958 when ground was broken for a new 326-bed hospital on Dempster Street between Greenwood Avenue and Potter Road.

On Christmas Eve 1959, the Lutheran General Hospital was formally dedicated. In time, it would become a nationally recognized leader in medical research and education. The cost of the initial land acquisition and construction was pegged at $7.6 million.

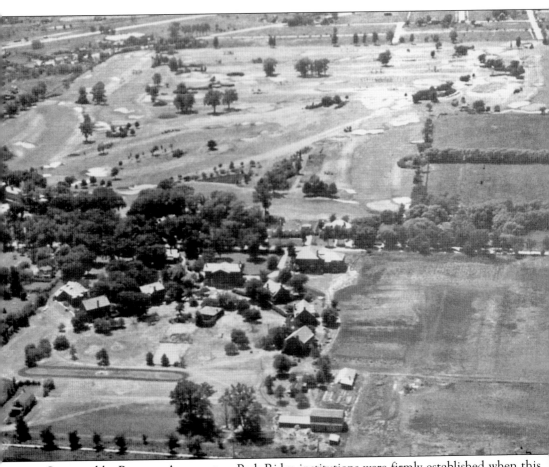

Separated by Prospect Avenue, two Park Ridge institutions were firmly established when this photograph was made in the early 1930s. At the top is the Park Ridge Country Club, and east of Prospect Avenue is the campus of the Park Ridge School for Girls.

By the turn of the 20th century, the city had long outgrown Penny's railroad station, which he built just south of Prospect Avenue in 1856. This larger depot (above) north of Prospect Avenue replaced it. In 1910, voters cast their ballots in the baggage room when deciding to reincorporate as the City of Park Ridge. Note that the right-of-way consisted of only two tracks in this early view. The second depot (below) served the city's residents until the late 1950s. Dedication of the third station took place in 1960. (Courtesy Park Ridge Public Library.)

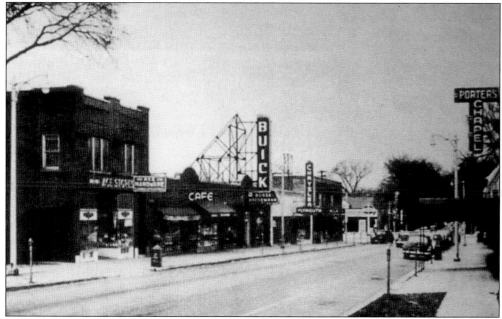

This 1950s view of north Northwest Highway is dominated by the Busse Bredemann Buick sign over the site formerly occupied by Kobow's Store. Roloff's hardware store to the left was the city's first Ace Hardware franchise. Porter's Chapel on the right occupied the former post office and later became a flower shop.

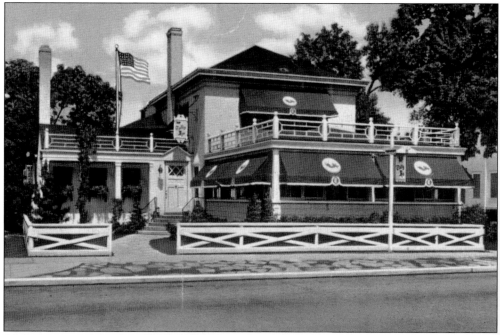

Evoking the image of an English foxhunt, the Tally-Ho Restaurant on South Northwest Highway was noted for its country charm. By the mid-1940s, it had become a destination for diners from far beyond the city's borders. Long gone, the site is now a Chase Bank parking lot. (Courtesy of Rick Cubberly.)

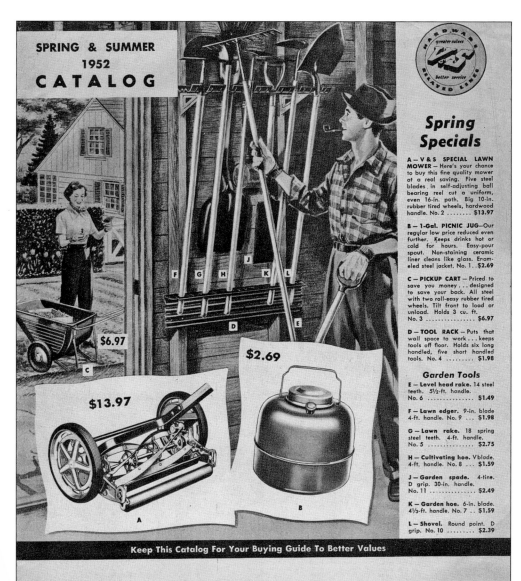

Nothing says spring like cleaning up the yard after the ravishes of winter and looking forward to a series of weekly lawn cuttings during April and May. Long before "going green" prompted a resurgence of hand-powered lawn mowers, they were standard fare, and Bachmann's offered one of the latest for less than $14. (Courtesy of Brian Lazzaro.)

This simple intersection was seemingly in the middle of nowhere in 1955, but both Higgins Road and Cumberland Avenue were destined to become major thoroughfares as commercial development cropped up on all sides. This view is looking east on Higgins Road. (Courtesy of the Park Ridge Historical Society.)

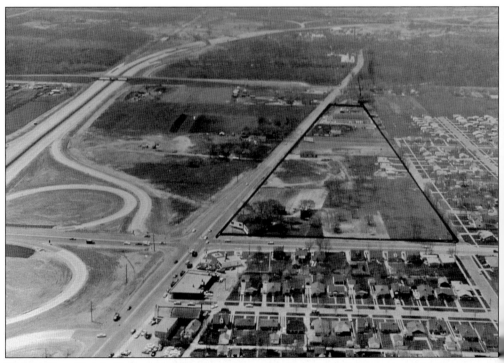

Probably Pres. Dwight D. Eisenhower's most visible and lasting legacy is the interstate highway system launched during his administration. The Cumberland Avenue interchange with the Northwest Expressway—later renamed in memory of the 35th president—nears completion on the left.

This small cluster of mutually complimentary homes on Cedar Street between Prospect and Meacham Avenues exhibits an early example of planned residential development. A more utilitarian housing concept appeared throughout the city during World War II, with the advent of the "defense Georgian" (below), built to house workers employed by the Douglas Aircraft plant at Orchard Field, now O'Hare Field. With just 800 square feet of living space, they were cramped units but efficient. (Above, courtesy of Dave Chare; below, author's collection.)

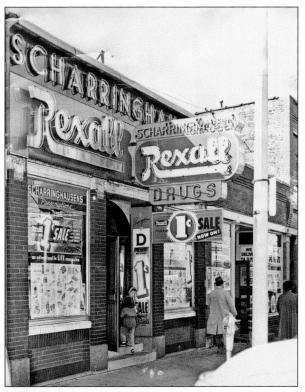

After surviving the Great Depression and sharing cramped quarters with Michael Schiessle at 110 Main Street, Scharringhausen Pharmacy was back on solid footing by the 1950s having expanded into Schiessle's former office space. (Courtesy of Bill Scharringhausen.)

The soda fountain in the Buchheit Building was only a memory by the early 1950s, and Scharringhausen Pharmacy was offering the basics in drugs, cosmetics, and convenience-store items. The store's Rexall affiliation was boosted by the Sunday evening *Phil Harris and Alice Faye Show* on NBC, promoted by the sign in the upper left. (Courtesy of Bill Scharringhausen.)

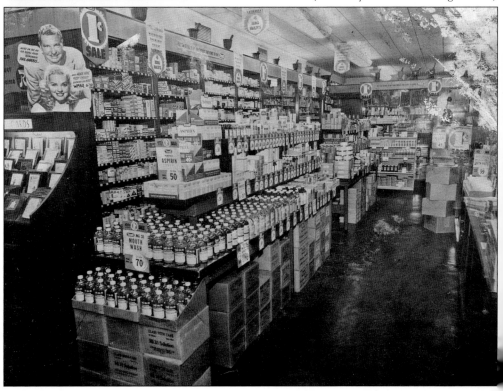

In the early 1960s, Woolworth's and the Park Ridge Plaza dominated the east side of South Northwest Highway. Anchored by Schultz Pharmacy, the plaza also housed Ann Thall's Vogue and Guth's Luggage and Gifts. The Tally-Ho restaurant can be seen to the left between Woolworth's and the Citizen Bank drive-in pylon. (Courtesy of Dave Chare.)

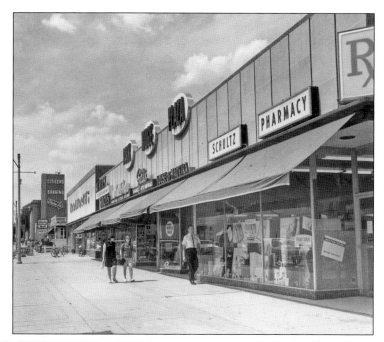

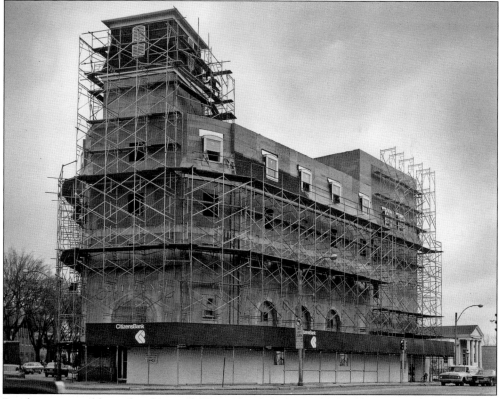

Barely recognizable under the scaffolding, the Citizens Bank building underwent a massive transformation in the early 1970s, including the addition of two stories, a clock tower, and a faux-brick exterior. (Courtesy of Dave Chare.)

The Gillick home at the northeast corner of Summit and Euclid Avenues served for a time as the first home of the Park Ridge Historical Society. It was subsequently razed to make room for the existing commercial development and parking lot stretching between Summit and Prospect Avenues. (Courtesy of Dave Chare.)

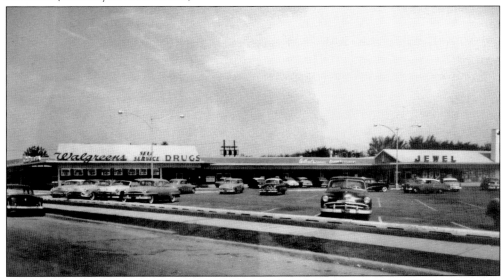

The brand-new South Park Shopping Center poses for a formal portrait in 1955. Developed by the Gillicks, it was anchored by Walgreen's and Jewel with Breen's Cleaners, later to become a menswear store, as a pioneering tenant. (Courtesy of Fred Gillick.)

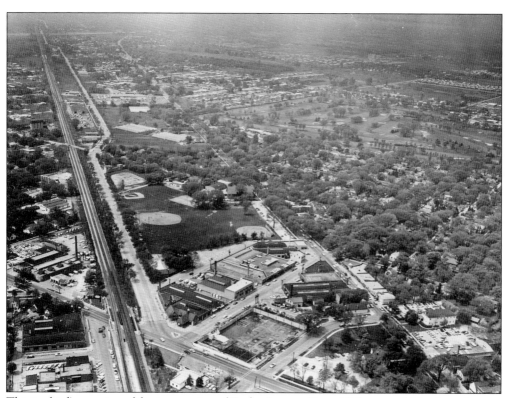

This is a bird's-eye view of the intersection of Touhy Avenue, Busse Highway, and Meacham Avenue in the late 1950s. The vacant square at the bottom center is the site of the future Park Ridge Inn. Where Busse Highway jogs to the right is the now-closed Elm Street railroad crossing. Right of where Busse Highway jogs back to the left are the Heinz greenhouses. (Courtesy of Dave Chare.)

The Oakton School campus dominates the lower half of the aerial view of Oakton Street between Busse Highway on the left and Northwest Highway on the right. The former National Food Store is now a McDonald's. (Courtesy of Dave Chare.)

It was a sign of things to come when Hillary Rodham (standing) was elected vice president of her junior class at Maine East High School. A much bigger prize eluded her in 2008—the presidency of the United States—but as Hillary Rodham Clinton she went on to become the nation's secretary of state. (Courtesy of Maine Township School District 207.)

Harrison Ford, the future Indiana Jones, graduated from Maine East High School in 1960. He was the first student voice to be broadcast over the school's new WMTH FM radio station and, during his senior year, was the station's first sportscaster. (Courtesy of Maine Township School District 207.)

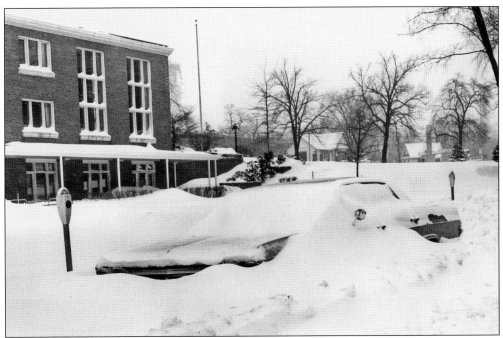

After experiencing a balmy 65 degrees two days earlier, Park Ridge residents awoke on the morning of January 26, 1967, to a snowstorm that began just after 5:00 a.m. Four inches had been predicted, but when the storm ended 29 hours later, cars were buried and roads were impassable. (Courtesy of Dave Chare.)

No trains were running during the morning commute on Friday in the wake of the day and night-long storm that blanketed the city with an official 23 inches of heavy, wet snow. (Courtesy of Dave Chare.)

Around 1938, the city constructed a central water reservoir near the site of its original artesian well at Touhy Avenue and Northwest Highway. It was expanded in 1956 and 1957, but increased demand required further expansion in 1969. Plans for redevelopment of the Touhy Avenue, Northwest Highway, and Summit Avenue triangle forced the reservoir to be abandoned in June 2005 with the switch to the new Hinkley Field water storage facility. (Courtesy of Dave Chare.)

Concrete is the answer to basement flooding on the north side of the city; huge sections of storm sewer pipe stand ready in the early 1970s to be buried under Oakton Street. The sewer was designed to carry rainwater runoff to the Des Plaines River. (Courtesy of Dave Chare.)

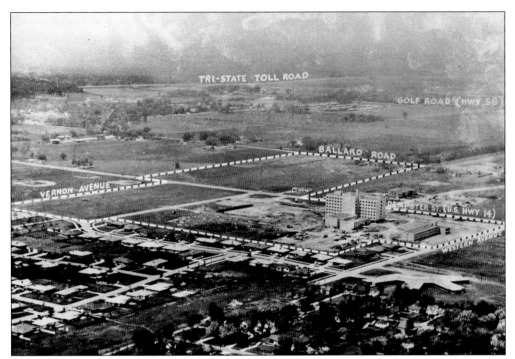

"Make no small plans" Daniel Burnham is said to have said, and although open only a few years, Lutheran General's directors were already looking to future development as a comprehensive medical complex as shown in this view looking toward the northwest. (Courtesy of Lutheran General Hospital.)

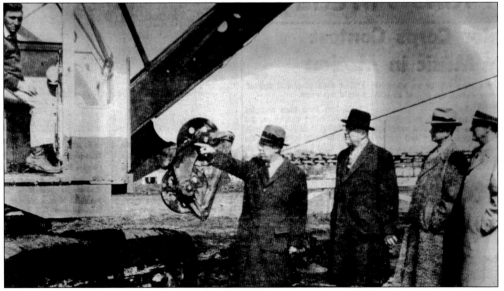

In April 1958, general contractor William Schweitzer (pointing) instructs an unidentified power shovel operator to start digging, launching the construction of Lutheran General Hospital. Looking on are, from left to right, Fred Mathison, hospital board treasurer; Virgil Nelson, executive director; and N. M. Nesset, president of the Lutheran General Board of Directors. (Courtesy of Lutheran General Hospital.)

Composer Meredith Wilson chats with Alex and Frances Harley during a guest appearance at Maine East High School. During his tenure as band director at Maine East, Harley founded the Modern Music Masters in 1936 to honor particularly talented students. Now known as Tri-M, the organization numbers more than 1,000 chapters across the United States and around the world. (Courtesy of Don Pfister.)

A long-established tradition for raising political campaign funds has been to bring in one of the big guns to speak soothing words to the party faithful. And no politician was better at it than the golden-voiced U.S. senator Everett M. Dirksen. Gathering at such a fund-raiser in the mid-1960s were, from left to right, state representative Robert Juckett, U.S. congressman Harold Collier, Dirksen, and state senator John W. "Bill" Carroll, publisher of the *Park Ridge Advocate*. (Courtesy of Don Pfister.)

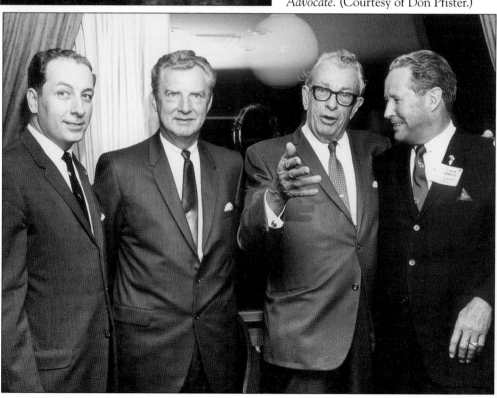

The wrecking ball makes short work of the old Park Ridge Fuel and Material silos at Elm Street and the Chicago and North Western tracks in the late 1960s, making room for a new public works building to be constructed at 1200 Elm Street. (Courtesy of Don Pfister.)

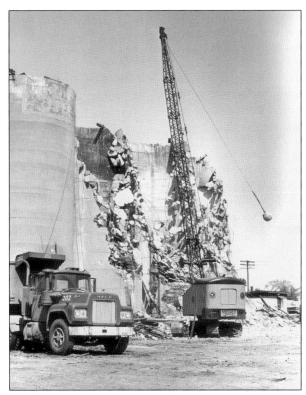

A toppling chimney marks the end of an era that began in the 1880s and ended in the 1960s, as the last of the city's greenhouses is cleared from the tract bounded by Greenwood Avenue, Busse Highway, Elm Street, and Northwest Highway. Formerly the site of the Heinz greenhouses, it is now developed with the post office, Jewel-Osco, a bank, and three-story office buildings. (Courtesy of Dave Chare.)

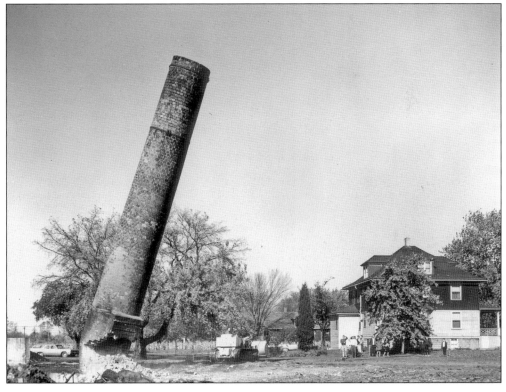

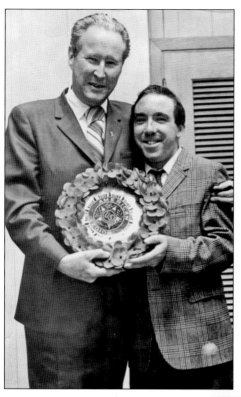

His given name was Herman Kartheiser Jr., but to the local business community, he was better known as "Chickie." Developmentally handicapped, he made friends easily and was a fixture in town from the early 1960s until his death in 1991 at age 47. He was probably best known for donning the stars and stripes to lead virtually every local parade that trod the city's streets, but he was also an avid tin can recycler. Here state senator John W. "Bill" Carroll congratulates Chick for an American Legion Award ringed with poppies. (Courtesy of the Kartheiser Family.)

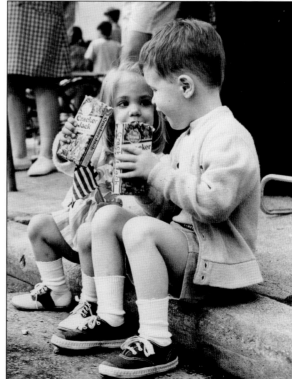

Nothing says Americana like a parade, a flag, Cracker Jacks, and a couple of kids. Settling in for the 1970 Memorial Day Parade are Adria Barnes and Tommy Schaefer. (Courtesy of Don Pfister.)

Six

THE ART COLONY

In 1897, Frederick Richardson, an instructor at the Art Institute of Chicago (AIC) moved to Park Ridge to claim the hand of Josephine Welles. Josephine was the daughter of George S. Welles, a wealthy coal merchant, former village president, and amateur silversmith.

At about this time, an Oregon native named Clara P. Barck was studying design at the art institute; in 1900, she and five other female AIC graduates opened a small studio in the Bank of Commerce Building in Chicago. They called their business "Kalo," a Greek word meaning "to make beautiful."

Richardson introduced his father-in-law, who was divorced, to Clara since both shared a mutual interest in the Arts and Crafts Movement that was beginning take root in the United States. In 1905, Clara and George tied the knot.

More than a dabbler in the Arts and Crafts Movement, Clara proved to be a woman with a mission. She was determined to make arts and crafts a paying business. Soon after their marriage, George and Clara purchased "the big house," a rambling frame structure at 322 Grant Place, which she converted into a workshop and school that she called the Kalo Arts Crafts Community.

To help turn out articles that were "beautiful, useful and enduring," Clara hired several European craftsmen, including Julius O. Randahl, Matthias Hanck, Yngve Olsson, and Henri Eicher, who soon became the shop foreman. By 1913, the Kalo Shop was the city's second biggest business and one of its major employers with about 25 craftsmen—and women—on its payroll.

While Clara was building her business, two of Richardson's painting students, Albert H. Krehbiel and Dulah Marie Evans, married and moved to Park Ridge to join the emerging artists colony. Albert would become a highly regarded muralist, winning a commission to decorate the Illinois Supreme Court building. For her part, Dulah teamed up with Beulah Clute in 1910 to form The Colony Crafts, turning out greeting cards, calendars, and bookplates.

Meanwhile, the art colony continued to grow. In 1914, an Italian sculptor named Alfonso Iannelli moved from California to work on a project called The Midway Gardens under the eccentric Frank Lloyd Wright. In time, Iannelli's works would be featured throughout Chicagoland, including the 1933 World's Fair.

By the 1970s, the colony had all but disappeared after having left its indelible mark on the world of fine art and craftsmanship.

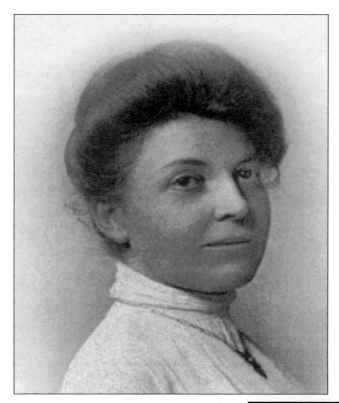

In 1900, Clara Barck and five other female students at the Chicago Art Institute School of Design opened a small studio in Chicago that they named Kalo, a Greek word meaning "to make beautiful." After marrying former Park Ridge mayor and amateur silversmith George S. Welles in 1905, she moved her studio to "the big house" at Grand Boulevard and Clinton Street, attracting highly talented silversmiths and effectively establishing what would evolve into the city's art colony.

One of three prominent sculptors to make his home in Park Ridge was John Paulding, although he kept his studio in Chicago. His most prominent local work in the early 20th century was the design of Johnston's Circle at the current intersection of Prospect Avenue, Touhy Avenue, and Northwest Highway, complete with two drinking fountains and two horse troughs—all fed with the artesian well a few feet away. He was also instrumental in the design of the first library building.

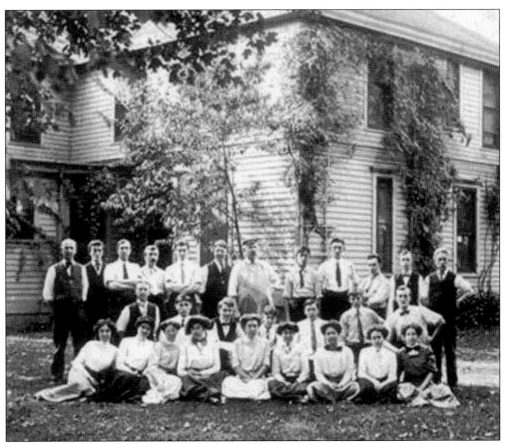

The "big house" at Grand Boulevard and Clinton Street employed as many as 25 jewelers, silversmiths, and other artisans whose internationally famous handcrafted items can command five-figure prices in today's market. The shop closed in 1970 after its founder, Clara Barck Welles, died in California at age 97.

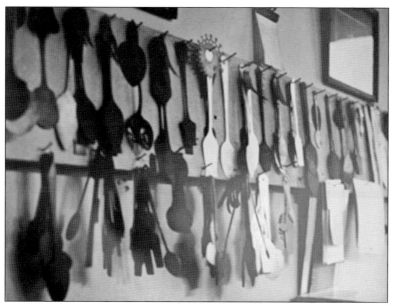

The tools of the trade hang in the Kalo workshop. In the hands of such acclaimed silversmiths as Julius Randahl, Matthias Hanck, Werner Von Buelow, and Yngve Olsson, these tools produced a variety of products, ranging from flatware to bowls and pitchers to intricate jewelry.

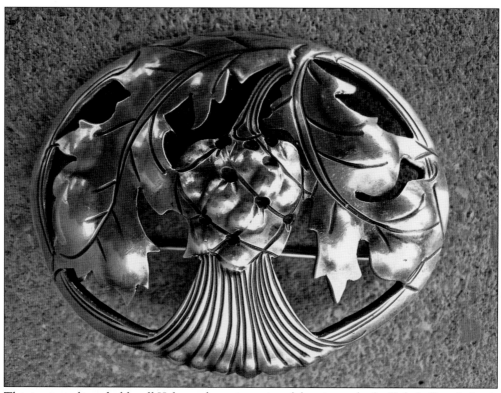

This intricate brooch, like all Kalo products, is unsigned, bearing only the Kalo hallmark, but it was designed and crafted by Yngve Olsson.

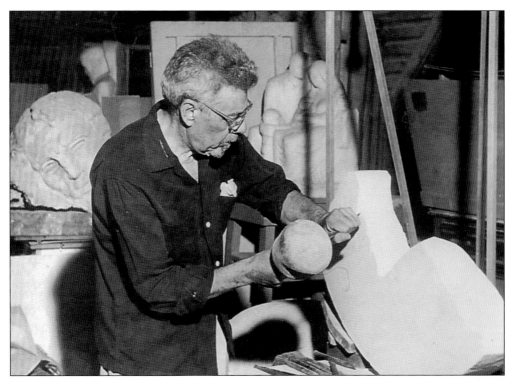

Just look around town and one will see the genius of Alfonso Iannelli in some of the most unlikely places; it could be the fountain in Hodges Park or the marquee on the Pickwick Theater. He is internationally known for the sprites in Midway Gardens that he designed for Frank Lloyd Wright in 1914, and he is believed to have drawn the plans for the gatehouse at the Town of Maine Cemetery.

Eugene Romeo, one of the city's trio of acclaimed sculptors, was born in Italy, raised in Brooklyn, and moved to Park Ridge in 1934. Working in bronze, marble, iron, and plaster, his international commissions included the Shedd Aquarium, Soldier Field, the Chicago Board of Trade, and Civic Opera House. The *Rock of Gibraltar* gracing the face of the Prudential Building in Chicago is among his most visible legacies.

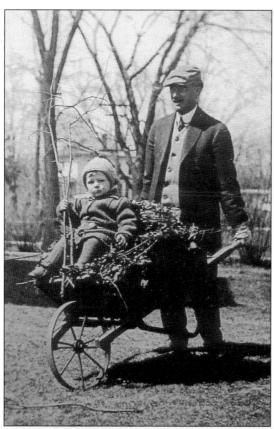

Famed muralist Albert Krehbiel gives his son Evan a ride at his home on North Washington Avenue. His wife, Dulah, was an illustrator who opened her own Park Ridge studio, turning out greeting cards, postcards, and decorated china, assisted by another artist named Beulah Clute.

Albert Krehbiel's studio on Center Street is now the location of an office building at 325 West Touhy Avenue. The studio, to the right, was a converted barn that had been moved to the site and modified with a panel of windows to take advantage of the north light.

Kalo Shop foreman Henri Eicher and his wife, Asta, often opened their home at 312 Cedar Street to fellow Kalo employees who worked after hours on their own silver and jewelry creations. After Henri died, Asta was wooed by a serial killer who murdered her and the couple's three children in 1931 (see page 113). (Author's collection.)

The garage behind the Eicher home once served as home and studio for Kalo Shop silversmith Grant Wood. After leaving Kalo, Wood took up oil painting, creating one of America's best known paintings, *American Gothic*, in 1930. Wood died in 1942 at age 51, but the painting lives on in the Art Institute of Chicago. (Author's collection.)

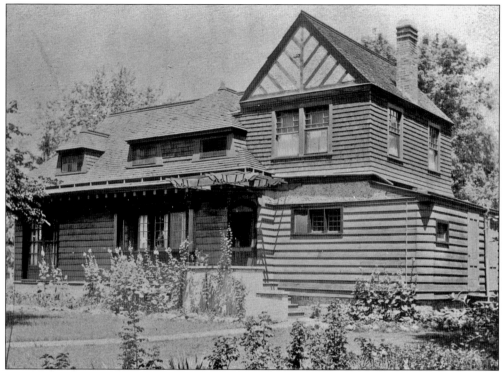

Another faculty member of the Art Institute of Chicago to settle in Park Ridge was portrait painter Walter Marshall Clute, who converted a barn into a studio and added living quarters to the barn. It was later home to a young Sam Guard, who remembered it being used for a time as a studio for WLS Radio.

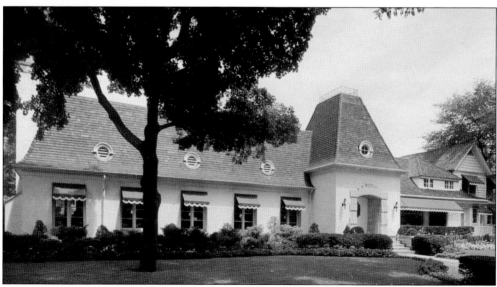

Further expanded and upgraded, the Clute studio at 720 Garden Street would become Bob Fischer's Pantry Restaurant and then Al Wohler's insurance agency. Currently the building serves as a multi-tenant office facility for a variety of community-based nonprofit agencies. (Courtesy of Rick Cubberly.)

After striking out on his own, Werner Von Buelow began crafting fine silver pieces in this humble shack at Summit Avenue and Northwest Highway. As his business prospered, he would move his studio to the second floor of the Ridge Theater and then on to the former Park Ridge State Bank building, which had been moved a block south to make room for the Pickwick Building. (Courtesy of Andrew Wilson.)

While still concentrating on producing silver jewelry, hollowware, and flatware, Von Buelow decided to add watchmaking to his repertoire sometime after moving to the second floor of the Ridge Theater. Here three of his watchmakers ply their craft in the Ridge Theater studio. (Courtesy of Andrew Wilson.)

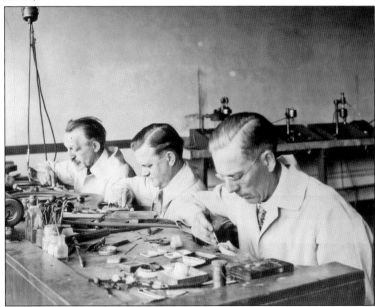

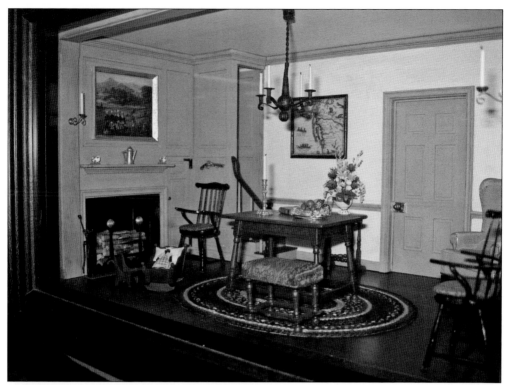

It was a remarkable resume, and it worked to launch Eugene Kupjack on a career as one of the United States' most respected miniaturists. After reading in 1937 of Narcissa Thorne's creation of miniature rooms, Kupjack sent her—unsolicited—a miniature chair he had made with what appeared to be a glass plate and goblet. She was impressed, launching an association that lasted until Thorne's death in 1966. This room, one of some 900 that Kupjack created, is on display at the Park Ridge Public Library. (Courtesy of A Sterling Design.)

No matter how finely modeled the 1/12th scale furniture may be, it is the details that give a Kupjack room its character. Working in his Park Ridge studio, Kupjack crafted such detailed accessories as this Lilliputian silver teapot to add a look of livability to one of his shadowbox-sized rooms.

Seven

TO SERVE AND PROTECT

When Charles Duwell stepped off the train on August 12, 1874, the village of Park Ridge was just over a year old with a population numbering a little more than 400 souls. The police force consisted of a town marshal and a few volunteers who were on call at any hour of the day or night.

Duwell first turned to Penny and Meacham's brickyard for employment, but in 1892 he joined the village's first regular three-man police force along with Claus Hamer and Charles More, who served as captain.

"I had 123 kerosene street lamps to light before going on duty each night," Duwell later recalled. His salary was $45 a month. In 1901, Duwell was named police chief, a post he held until he retired in 1928. By then, the force had grown to a dozen men with two squad cars and three motorcycles.

It was during the administration of Duwell's successor, Chief Harold Johnson, that Park Ridge made national headlines as a setting for the "Lonely Hearts Murder" case. In July 1931, Asta Eicher, the widow of former Kalo Shop foreman Henri Eicher, announced her new romance with Cornelius O. Pierson. They had met through a dating service called Detroit's American Friendship Society.

Pierson, whose real name was Henry Powers, described himself as a "wealthy widower worth $150,000" with a monthly income of $2,000. He claimed to have a brick, 10-room home among his assets. Asta said "Cornelius" would be moving into her home at 312 Cedar Street and asked William O'Boyle, a boarder, to find other accommodations.

But Asta and her three children disappeared, never to be seen alive again. On August 28, their bodies were discovered on Powers's farm in Quiet Dell, West Virginia, along with the body of another woman named Dorothy Lemke—all had been murdered. After a speedy trial, Powers has hanged on March 18, 1932.

The village's volunteer fire department was organized in 1893 but had to wait a full year before it had any equipment to actually fight fires. By 1895, the department numbered at least 20 volunteers.

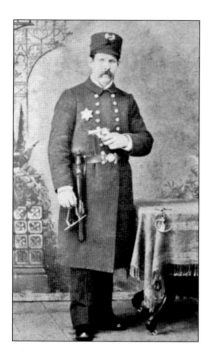

It was a brand-new village when Charles Duwel began serving on the village's three-man police force. But when he retired as Park Ridge's first police chief in 1928, it had been reincorporated as a city. A transplant from Toledo, Ohio, he first worked in Penny's brickyard before joining Charlie More and Claus Hamer in 1874 as a volunteer lawman for $45 a month. He was appointed chief in 1901.

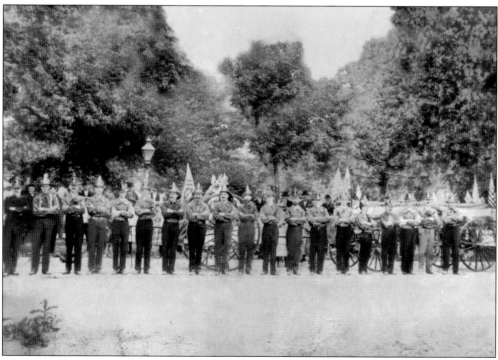

They may have been volunteers, but their uniforms spoke of a professional attitude. It was not until 1922 that the first paid firemen were added to the force with volunteers continuing to serve as late as 1969.

In 1931, Asta Eicher and her three children mysteriously disappeared from their home at 312 Cedar Street, triggering national headlines when their bodies were discovered on a farm near Quiet Dell, West Virginia. The 50-year-old widow of the Kalo Shop's former foreman, Asta, along with Greta (14), Harry (12), and Anabel (9), had been lured east with the promise of marriage by a man calling himself Cornelius O. Pierson. Instead, he hanged them and buried their bodies next to another victim named Dorothy Lemke.

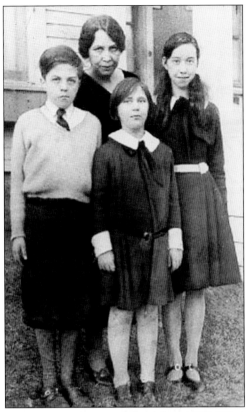

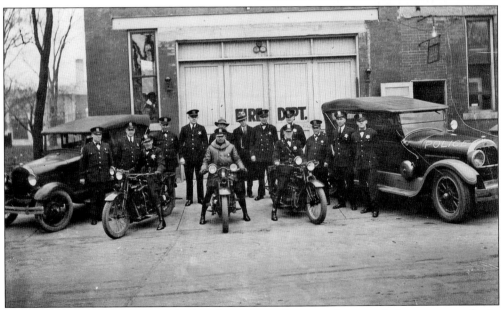

In 1929, the police department displayed its two modern patrol cars and three motorcycles in front of its headquarters in the old city hall at Touhy Avenue and Northwest Highway. Note the large bell on the right side of the car on the right, the precursor to today's siren. (Courtesy of the Park Ridge Historical Society.)

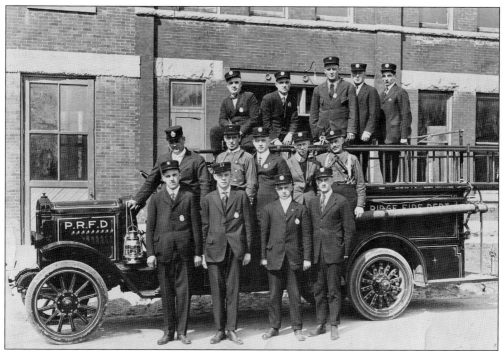

The 1921 Nash fire truck, shown here (above) at the old city hall soon after its delivery, was converted in 1934 to a Pirsch pumper (below) and served as a backup engine into the 1950s. After being retired, it was sold to Drake and Son Funeral Home and appeared in local parades before heading to the Fire Museum of Memphis (Tennessee), where it remains on display. (Above, courtesy of the Park Ridge Historical Society; below, Brian Lazzaro.)

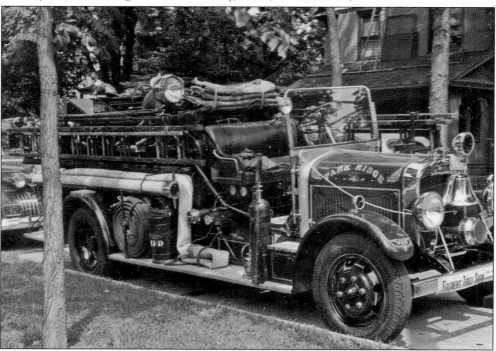

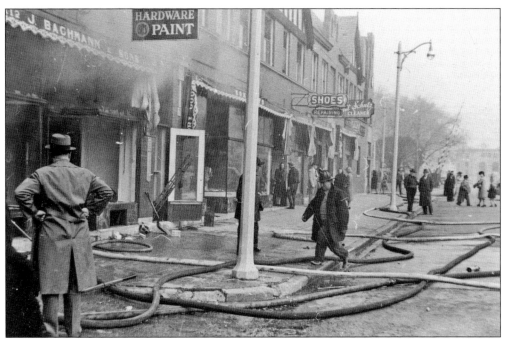

On March 20, 1940, a fire gutted the J. Bachmann and Sons hardware store at the south end of the Gillick Building. Established in 1927 by Jon Bachmann and his son Urban, the store was moved after the fire to temporary quarters in a former post office building at 29 South Fairview Avenue. It later moved to its final home at 122 South Prospect Avenue. (Courtesy of Fred Gillick.)

Nothing draws a crowd like fireworks, and the Bachmann fire was no exception. South Prospect Avenue was crowded for more than a block with spectators as smoke continued to erupt from the ill-fated store to the far left of the photograph. (Courtesy of Fred Gillick.)

The Meacham Avenue fire station as it appeared in 1950 served as the department's only location from 1948 to November 1970, when the equipment was distributed between the new south side and north side stations. In the bay to the left of the pumper on the apron is the 1934 Pirsch engine that still served as a backup. (Courtesy of Don Pfister.)

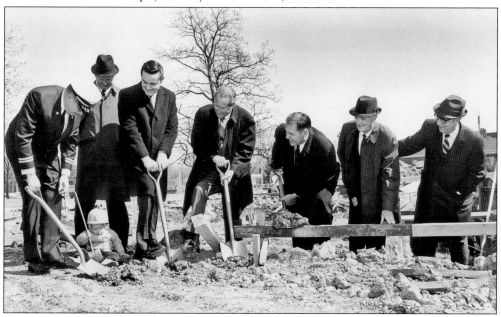

Stealing the spotlight during the 1968 ground-breaking for the new south side fire station at Devon and Cumberland Avenues is "Normie" Brown, the young son of Chief Norman Brown. Distracted by his antics are, from left to right, Chief Brown, an unidentified alderman, public works director Tom Fredrickson, state senator John W. "Bill" Carroll, Mayor W. Bert Ball, city clerk Paul Badger, and city manager James Galloway. (Courtesy of Don Pfister.)

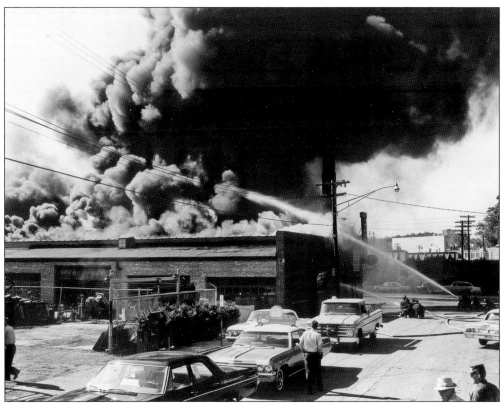

Shortly after opening for business on June 9, 1963, a small fire broke out in the Spradlin Chevrolet service area. Quickly spreading to the wooden truss roof, the Meacham Avenue building was doomed, even as firefighters began hooking up their hoses to the hydrants and pumpers. The loss was set at $200,000. (Courtesy of Dave Chare.)

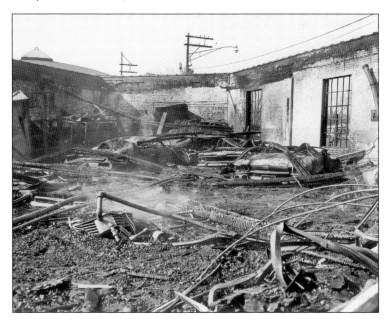

Casualties of the Spradlin fire smolder in a corner of the Chevrolet dealership's service area. Several cars were rescued, but the flames spread too fast to save them all. (Courtesy of Dave Chare.)

The fire department took delivery of its first ambulance in 1969. Prior to buying this specially equipped Cadillac, the city relied on Ryan-Parke Funeral Home to provide emergency ambulance services. Ranged behind Chief Norman Brown (front left) and Lt. Jim Forton (front right) are new paramedics Bernard Arends, Leonard Dabler, Ed Kellan, Dave Hardie, and Jim Emerson. (Courtesy of Don Pfister.)

Homeward-bound commuters were held up near the Dee Road station on the afternoon of March 24, 1967, as one of the Chicago and North Western's F-3 diesel locomotives catches fire. No injuries were reported; only frayed nerves among the train's passengers. (Courtesy of Don Pfister.)

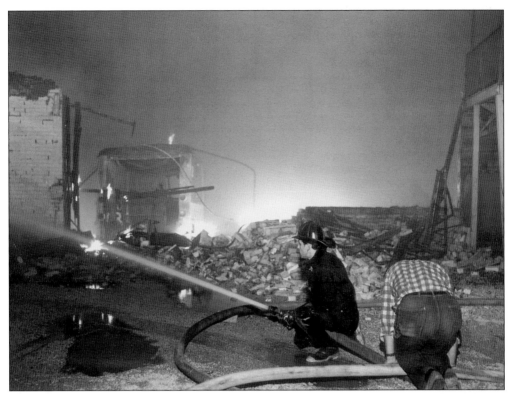

The second major fire to strike a Meacham Avenue business in less than a decade leveled the APCOA automobile painting shop at Meacham Avenue and Northwest Highway during the wee hours of May 12, 1966. A grateful William Hartigan, owner of the adjacent Hartigan Oldsmobile-Cadillac agency, publicly thanked the Park Ridge, Des Plaines, and Niles Fire Departments for saving his dealership. (Courtesy of Dave Chare.)

When a fire broke out at the St. Hedwig Orphanage at Harlem and Touhy Avenues, the Niles Fire Department called for the Park Ridge ladder truck to reach the upper floors. Speeding the ladder truck east on the westbound lane of Touhy Avenue, retired Capt. Ralph Bishop later recalled, "All I could think of was orphanage and fire." (Courtesy of Don Pfister.)

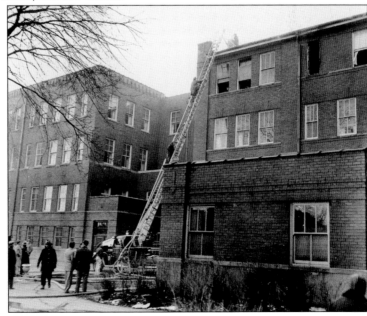

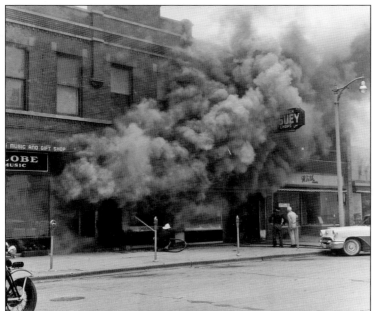

More than half a century of local ambience was wiped out in the late 1950s when Robinson's Candy Shop at 33 South Prospect Avenue was destroyed by fire. A popular gathering spot since it opened in the early 1900s, it served snacks and ice cream to such youngsters as Harrison Ford and Hillary Rodham (Clinton). (Courtesy of Don Pfister.)

During a May 1969 dinner marking the retirement of the city's last remaining volunteer fire fighters, Park Ridge Chamber of Commerce president Bill Scharringhausen presents plaques of appreciation to Chief Norman Brown and assistant chief Allen Angsten. Although Brown was named full-time chief seven years earlier, he had previously served as a volunteer since 1935. (Courtesy of Don Pfister.)

Eight

THE SECOND CENTENNIAL

In 1973, the city banded together to celebrate the 100th anniversary of its incorporation as a village. Highlights ranged from a battle of the bands featuring the Cavaliers Drum and Bugle Corps to watermelon eating contests, old-fashioned three-legged races, a guest appearance by disc jockey Larry Lujack, a Fourth of July kiddie parade, and a beard-growing contest.

Thirty-seven years later, Park Ridge celebrates its second centennial, this time marking its reincorporation as a city. The changes to Park Ridge during its first 100 years were dramatic: muddy roads were paved over, a municipal water supply was developed and refined, telephone lines were strung to virtually every house and business in town, and pioneering businesses like Scharringhausen's and Moheiser's became household names.

But there were other significant, though less dramatic, changes between the city's first and second centennial. More than 80 years after Henry J. Moheiser launched his business on Vine Avenue, his grandson Rick Cubberly closed the doors for the last time. William Scharringhausen retired from the family business begun by his grandfather George Scharringhausen Sr. in 1924. And the real estate business founded by Fred I. Gillick at the turn of the 20th century was transferred to Koenig and Strey by his grandson, also named Fred.

Scores of modest homes throughout the city were replaced with lot-filling mini-mansions and specialty shops along Prospect Avenue gave way to national chains such as Subway and Starbucks. Across the street, the library experienced another growth spurt, offering computer, audiovisual, and other services that were hardly imaginable in 1973. New train stations replaced existing ones at Prospect Avenue and Dee Road.

The triangle bounded by Touhy Avenue, Northwest Highway, and Summit Avenue was blanketed with a five-story retail and condominium complex after the central water reservoir was moved to Hinkley Field. The former Park Ridge Inn received a face-lift. And Lutheran General Hospital offered a dramatic, new eight-story facade to passersby after adding 192 more single-bed rooms to its sprawling health care complex.

But with all the changes made to the appearance and retail mix of the city, it still maintained the overall vision of its early developers to remain primarily a community of homes, served by good schools, parks, and comprehensive municipal services. "Out of the smoke zone; into the ozone" was Fred I. Gillick's way of summarizing his vision of his hometown's future. More than 100 years later, he probably would be pleased.

Constructed of Brickton bricks in the 19th century, it served as a home and nursery school—Mimi's Merry Mornings (above) was established in 1948 by Mimi Stidham. The school and the building are now gone, replaced in the 21st century by this home at Prospect Avenue and Cedar Street (below) that was built with more contemporary bricks. (Above, courtesy of Dave Chare; below, author's collection.)

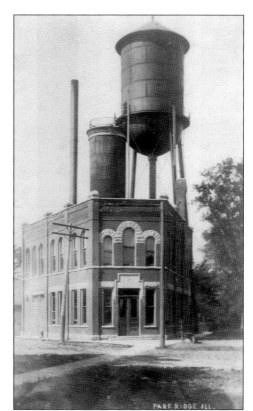

This building (right) dominated the western corner of Touhy Avenue and Northwest Highway from 1896 until 1948 and served as police station, fire department, waterworks, and city hall. Now (below) a more imposing five-story retail and condominium complex blankets the triangle that once was a playground for the Carpenter children and their friends. (Both author's collection.)

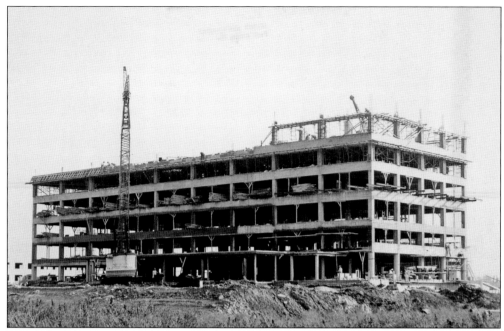

The skeletal framework of a long-awaited Lutheran General Hospital rose from the landscape in 1958, but it was only the beginning of a constantly expanding medical complex geared to meet the growing needs of the community it serves. On July 12, 2009, the hospital dedicated its latest expansion (below), the eight-story, 192-room tower displaying a bold new face to Dempster Street motorists. (Above, courtesy of Lutheran General Hospital; below, author's collection.)

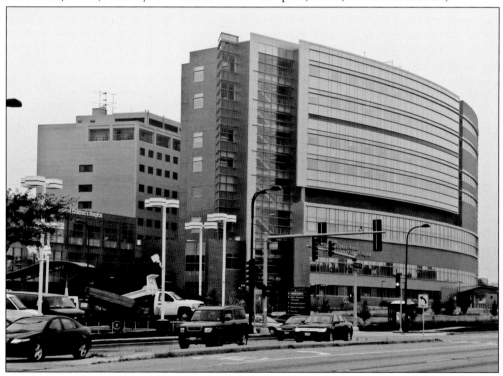

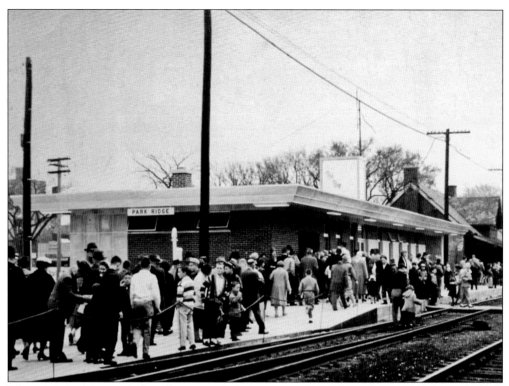

The second of the city's four downtown train stations was built at the turn of the early 20th century (see page 87) and replaced in the 1950s with a minimalist flat-sided box (above). Both inside and out, the latest version (below), dedicated in May 1996, closely mimics the character of its earlier predecessor. (Below, author's collection.)

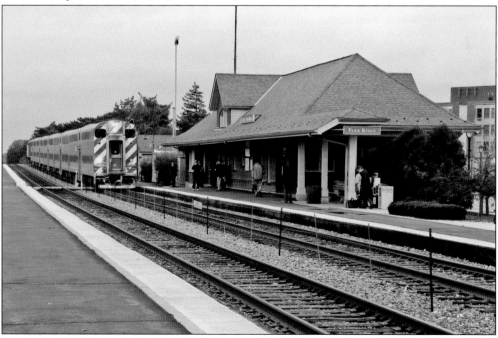

www.arcadiapublishing.com

Discover books about the town where you grew up, the cities where your friends and families live, the town where your parents met, or even that retirement spot you've been dreaming about. Our Web site provides history lovers with exclusive deals, advanced notification about new titles, e-mail alerts of author events, and much more.

MADE IN THE USA

Arcadia Publishing, the leading local history publisher in the United States, is committed to making history accessible and meaningful through publishing books that celebrate and preserve the heritage of America's people and places. Consistent with our mission to preserve history on a local level, this book was printed in South Carolina on American-made paper and manufactured entirely in the United States.

This book carries the accredited Forest Stewardship Council (FSC) label and is printed on 100 percent FSC-certified paper. Products carrying the FSC label are independently certified to assure consumers that they come from forests that are managed to meet the social, economic, and ecological needs of present and future generations.

FSC
Mixed Sources
Product group from well-managed forests and other controlled sources

Cert no. SW-COC-001530
www.fsc.org
© 1996 Forest Stewardship Council

Find Your Place in History.